theartist's
ProblemSolver

theartist's
ProblemSolver

Practical solutions from top professional artists for
painting in watercolours, oils, pastels and acrylics

First published in 2001 by
Collins, an imprint of
HarperCollins*Publishers*
77-85 Fulham Palace Road
Hammersmith, London W6 8JB

This edition first published in paperback in 2004

The Collins website address is:
www.**collins**.co.uk

Collins is a registered trademark of
HarperCollins Publishers Limited.

08 07 06 05 04
6 5 4 3 2 1

**A catalogue record for this book is available from
the British Library**

Editor: Geraldine Christy
Designer: Penny Dawes

The text and illustrations in this book were
previously published in *The Artist* Magazine.

ISBN 0 00 716571 4

Colour reproduction by Colourscan, Singapore
Printed and bound by Rotolito Lombarda, Italy

COVER: Detail from *Cherries in Porcelain Bowl*, Anuk
Naumann.

DETAILS (FROM THE TOP): *Two Garden Chairs*, Jackie
Simmonds; *Riva del Garda*, Gerald Green; *San Rocco,
Venice*, Winston Oh; *Flowers and Hat in Lamplight*,
John Lidzey.

CONTENTS

INTRODUCTION

The Artist's Practical Problem Solver has proved to be one of the most popular, helpful and longest-running series in the UK's The Artist magazine (first published in 1931). The aim of this ongoing series is to tackle students' most common painting problems by posing their questions to a variety of top-class artist-tutors, who are invited to offer advice and possible solutions to each problem through down-to-earth instruction, demonstrations and practical ideas.

As the series began to unfold in each monthly issue of the magazine, following the appearance of the first article in the January 1999 issue, I was asked by a growing number of readers about the possibility of developing the Practical Problem Solver series into book form, as a valuable reference guide. Happily, HarperCollins also thought that this would be a good idea: hence the collaboration between The Artist magazine and the book publisher to produce this new, practical art book with answers to the most frequently asked questions from the series.

You will find a host of different problems tackled here, of special value to painters with an interest in

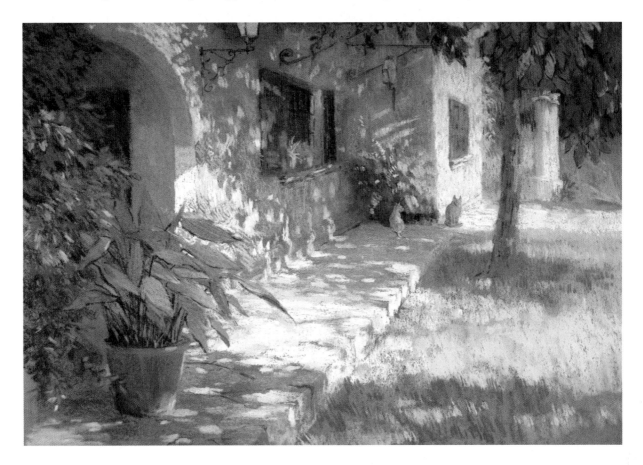

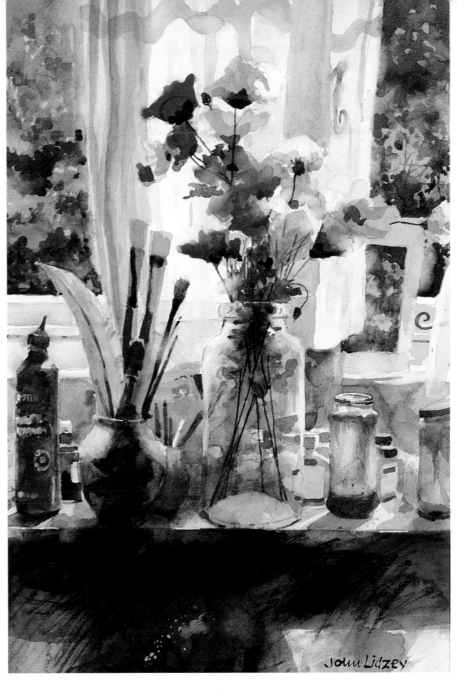

▶ John Lidzey,
**STUDIO WINDOW
IN SUNLIGHT**
watercolour, 43 × 28 cm
(17 × 11 in)

◀ Jackie Simmonds,
**GARDEN SHADOWS,
C'AN GAURI**
pastel on board, 46 × 66 cm
(18 × 26 in)

traditional subject matter: the basics of deciding on a good subject for a painting; how to convey depth and movement effectively; ways of coping with greens, painting skies, dealing with foregrounds; how to produce convincing figures and introduce them successfully into paintings; tackling backgrounds in still-life compositions; plus many other aspects of painting.

Each problem has been carefully considered by well-known artist-tutors, including Gerald Green, John Lidzey, Peter Partington and Jackie Simmonds, who offer sound advice based on their own approach to the subject in hand. The result is

a cornucopia of inspired ideas to help you overcome difficulties you may have encountered already during your painting life; maybe those that you are struggling with at the moment; or situations that you might very well face in the future. Whatever stage you are at I know that you will find the encouragement and advice you need here, helping you to progress, and enjoy your painting.

Sally Bulgin

Publishing Editor, *The Artist*

SUBJECT SPOTLIGHT

How do I decide what makes a good subject for a painting?

Answered by: **Gerald Green**

GARDEN, MALCESINE, ITALY
watercolour, 42 × 30 cm (107 × 75 in)

What caught my eye in this subject was the strong lighting. Strong tonal contrasts described the shapes of the elements in the picture. I made this sketchbook study using one warm colour, Burnt Sienna, and one cool colour, French Ultramarine. To maximize the impact of the light distribution I allowed the lightest areas to remain as white paper and then painted shapes rather than individual objects.

Talk to any gallery and you will invariably find that subject matter has a major influence on the picture-buying public. But to the artist the relevance of a subject is that it is simply the vehicle through which to express yourself at the time.

To begin with, what you choose to paint will often be influenced by the work of other artists whose particular painting style you admire. Or there may be a tendency to search for idealized or picturesque images that fulfil the preconceived notion of what you think a subject ought to include.

There may also be a desire to paint personal favourites that possess an emotional attachment or contain an element of nostalgia. The painting process then becomes an exercise in producing a 'nice' picture. This approach should always be avoided since the solution to deciding what might make a good subject lies not so much in what you choose but more importantly in what will be your response to it and how you are able to interpret it.

OBSERVATION
Recognizing potential subjects from your everyday environment or in seemingly ordinary or unlikely circumstances is an important part of artistic development. To do this you must first know how to look, in order to see with what is generally referred to as the 'artist's eye'. This means not merely looking, but observing nature in a particular way. Rather than looking at 'things' – flowers, still-life objects or elements in the landscape, for example – look particularly at the relationships between the various elements. Look for differing forms, shapes, lines formed between or linking different elements together, space, patterns and contrasts in tone, colour and textures. These more

abstract qualities are the essentials of 'seeing' in artistic terms and should also be used as the criteria for selecting prospective subject matter. Images in which you can see a variety of these elements are likely to make the most worthwhile subjects for making a painting.

To understand this way of seeing more fully try looking at a view that you know well, first in the normal way, and then by observing the abstract qualities described. Notice the difference in your perception of what you are looking at. In practice this may be made easier by imagining everything to be on a flat plane, or try looking through one eye only to reduce the effect of distance. Even when not painting you can train your 'artist's eye' by practising this way of seeing and soon it will become second nature.

SKETCHING

One reason why sketching is so important is that it exercises your ability in seeing. So explore your own visual environment, draw anything and everything, whatever happens to be in front of you. Do not just stick to your favourite subject matter.

Get into the habit of being a regular sketcher by always carrying a sketchbook and have it available for any convenient moment. There is an abundance of things around the home that can be used, from the general clutter inside the garden shed or garage to objects in the kitchen. Outside there are parks, gardens, parts of buildings or the clamour and hubbub of city streets; the choice is endless. The process of investigation through drawing will refine your visual awareness and awaken new directions for possible subject matter.

FINDING A FOCUS

How you are able to interpret what you see is also fundamental to your quest to find suitable subject matter. Images that contain a balanced composition with a well-defined focus will give clarity to a

HALLWAY
watercolour, 53 × 38 cm (21 × 15 in)

Still-life images can be combinations of any objects. Ordinary everyday items, perhaps of little significance in themselves, combine to make an interesting subject.

▲ SKETCHBOOK STUDY
watercolour, 28 × 38 cm (11 × 15 in)

When you begin to see with an 'artist's eye' you will discover potential subjects in even the most mundane situations. This display is almost a permanent feature in the corner of my studio and, though I look at it every day, until I painted it I realized I had not actually 'seen' it before.

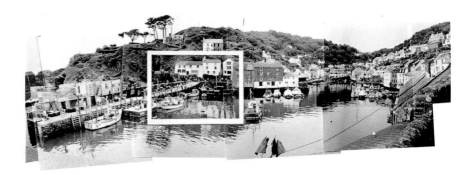

▶ *A viewfinder will help to isolate elements of a complex landscape view. The highlighted area is depicted in the drawing below.*

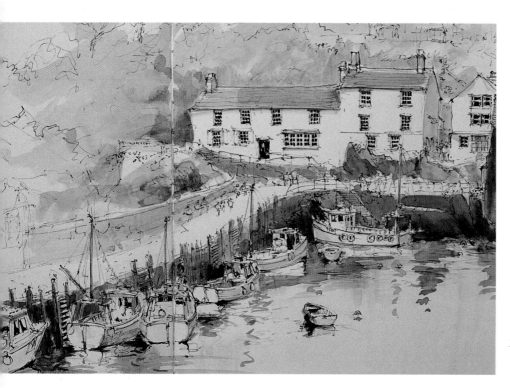

◀ **POLPERRO HARBOUR**
pen and watercolour,
30 × 42 cm (75 × 107 in)

Drawing is a more rapid method of recording the essentials of a subject as the basis for a later studio painting. In this sketchbook drawing I included a monochrome watercolour wash to register the general tonal distribution.

painting. Subjects do not have to be bustling with activity or depict wide vistas of landscape. A couple of flower stems in a jam jar, or other simple everyday things like brushes on a sink, can make rewarding subjects. Yet they are often overlooked, or not seen in the right way.

Because our eyes take in an angle of vision of almost 180 degrees we have become accustomed to viewing the world on a wide screen. But painting requires you to focus on the particular, much like a spotlight in a theatre selecting one element of the performance at a time. For landscape work, looking through a viewfinder can be a useful aid. This can easily be made by cutting a 7.5 × 5 cm (3 × 2 in) hole in a piece of card which, when looked through at arm's length, will enable you to see limited areas of the landscape in isolation.

This is useful for dissecting complex subjects, such as in *Polperro Harbour*. The photograph shows almost the full extent of the elevated field of view I had of a harbour setting. Though there were several subject opportunities here, I was attracted to the particular part of the scene, shown highlighted, by the tonal contrast between the white cottages set against the darker foreground elements, and the dominant angle of the harbour wall, which had the effect of leading the eye into the scene. I made the drawing to record the essential elements of the view. The addition of a monochrome wash also gave a record of the main tonal distribution.

Further opportunities for developing subject matter can be found by using on-the-spot drawings for later studio paintings, or by inventing subjects by combining parts from several drawings.

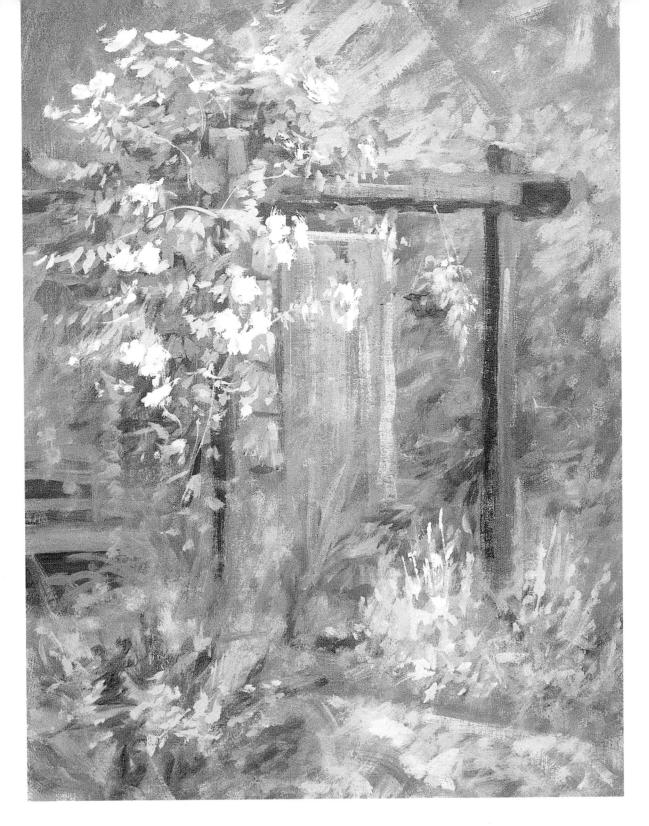

GARDEN CORNER

acrylic, 38 × 28 cm (15 × 11 in)

Many suitable subjects can be found in and around the home. This corner of my garden offered a ready-made composition with an amalgam of shapes, patterns and colours.

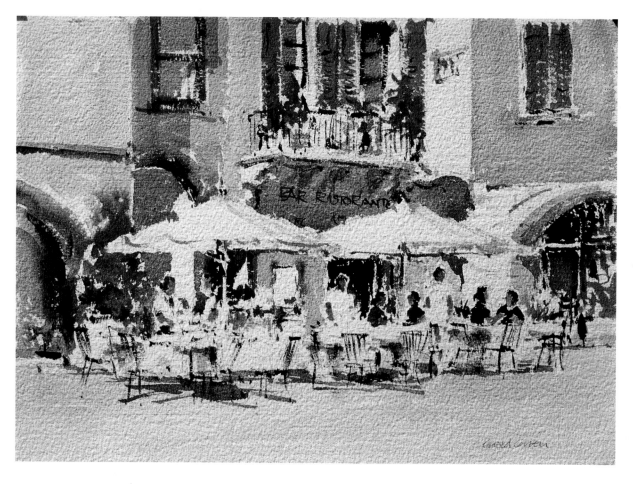

BRINGING SUBJECTS TO LIFE

Another major determinant in subject choice will be your ability and experience in using your chosen painting medium. If you are not adept at painting figures, for example, you will be far less likely to think of using them as possible subjects. But generally, whatever you choose, the best way to get the most from your subjects is to paint them in the most direct way you can. Aim for simplicity, both in your method of painting and means of expression. Do not try to create an exact copy, or produce a photographic likeness of your subjects.

Pavement Café illustrates a small corner of a large pedestrian piazza. I selected this area because the patterns of the shapes generated a lively composition, and my aim was to try to catch the essence of the subject with the minimum of detail.

Many of the problems that will confront you when painting can often be resolved by producing preliminary studies, either in monochrome or with limited colours, to help sort out doubts or uncertainties in the interpretation of your subjects.

PAVEMENT CAFÉ
watercolour, 25 × 36 cm (10 × 14 in)

This subject focuses on a small corner within a busy area of pavement cafés. I wanted the painting to portray the essence of the subject as simply as I could without allowing it to become overworked with detail.

These can be small thumbnail sketches, or larger studies similar to *Garden, Malcesine, Italy* on page 8. This was produced using one warm and one cool colour to establish the distribution of tonal values, direction of lighting and colour temperature (the relative warm/cool colour relationships) within the proposed image.

Preliminary studies will also allow you to try out different colour combinations in which perhaps you wish to convey mood or atmosphere. In *Winter Landscape* the mood was achieved by using complementary colours, yellow and purple, which when mixed gave a range of neutral colours tending to grey in the middle. This gave an unusual colour

cast to a wintry subject with the inclusion of a warm sky that, combined with using a middle range of tonal values (without the extremes of black and white) gave a more muted feeling to the painting in general.

Atmosphere is obtained principally by adjusting the quality of lighting in a painting. This can have the effect of reducing a subject to just a few simplified shapes. Paintings looking into the light, for example, will dramatically change the elements of a subject into a series of silhouettes.

So, wherever inspiration leads you, opportunities for subject matter exist all around you. All you have to do is to know how to look for them.

WINTER LANDSCAPE
acrylic, 51 × 61 cm (20 × 24 in)

Creating an atmosphere can transform seemingly uninteresting or commonplace landscape subjects. I based this studio painting on a small sketch that I made in the summer months. Closely related tones in combination with a restricted palette of yellow and purple gave a muted mood to the image.

CENTRE OF INTEREST

What is a focal point, and do I really need to worry about it unduly?

Answered by: **Jackie Simmonds**

Many wonderful pictures have been created by artists who have not bothered with a focal point; instead, these pictures tend to be about pattern and texture, a tapestry of shapes and colours. Nevertheless, I believe that a picture will always benefit from having one strong focal point – the centre of interest. A good way to think about a focal point is to create in your mind the picture of a stage full of dancers. The lights are set to wide beam, taking in the whole stage. Your eye darts from dancer to dancer, finding it difficult to concentrate on any one spot on the stage. Now imagine the lights dimming slightly, and a brilliant spotlight shooting out to illuminate one main dancer. Now you have no problem where to look: you are being directed to look in one spot, while your peripheral vision takes in the whole scene.

If you simply sit down to paint whatever is in front of you, without planning the composition, you run the risk of producing a weak picture, one without a sense of purpose. If the subject you select does not have an obvious focal point, you need to consider how to create one. A seascape, for instance, may have no obvious focal point – in fact, the sheer scale of an area of ocean makes it very difficult to focus on one spot – but for the picture to be interesting, the viewer's eye needs to be held within the rectangle, focusing on one dominant area to begin with, before moving on to examine the rest of the image.

HOW TO SELECT A FOCAL POINT

Ask yourself when you sit down to paint what it was that first attracted you to the scene. It may help to write this down in your sketchbook. If you cannot answer this question immediately – it is possible that you just liked the whole view – ask

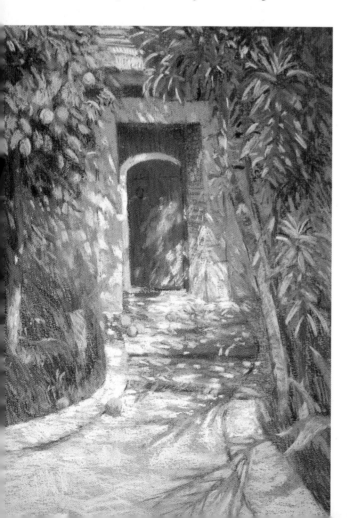

THE MOROCCAN DOORWAY
pastel on paper, 51 × 30 cm (20 × 12 in)

Here the viewer's eye is directed to the doorway by the lines of the pathway. A little obvious, perhaps, but it works well! The doorway is positioned off-centre, and on the top right 'eye' of the rectangle. Notice, too, that the edges of the pathway, where they meet the edges of the rectangle, are asymmetrically placed. Positioning them at exactly the same point, to the left and to the right, would have been rather boring.

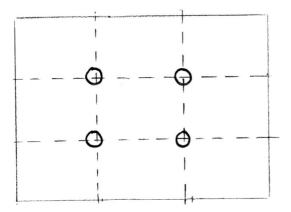

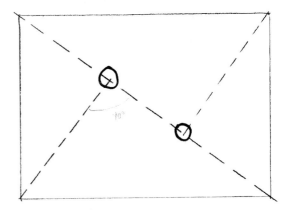

Divide the paper or canvas into thirds, vertically and horizontally. Where the lines cross, these are the 'eyes' of the rectangle, perfect spots on which to position a focal point or area. My diagram shows all four, but you would only use one, ideally, for your main focal point.

Divide the picture into two, from corner to corner. Then bring a line down from one of the other corners, to cross the first line at right angles. Where the lines cross, is the 'eye' of the rectangle, or focal area. In my diagram you can see two alternatives.

yourself what you would best like to emphasize, or draw particular attention to. Sorting out your thoughts before you commit to paper is an important part of the process of painting. It does not mean that these ideas and thoughts are set in stone; you might decide to change the emphasis during the process of painting – but it certainly will help your confidence, and sense of direction, to have a good, positive starting point. Deciding on what is most important in your picture will give the picture meaning; your reason for choosing that particular scene will be clear to the viewer.

HOW TO POSITION YOUR FOCAL POINT

You should always aim to direct the viewer's eye into and around the picture. Therefore, the placing of the main elements of the picture is crucial. Artists through the centuries have used the 'golden section' – a way of dividing the rectangle that is somewhat complicated, but worth exploring (see Bernard Dunstan's book *Composing your Paintings* published by Studio Vista). A simpler way is to divide your rectangle as in either of the diagrams above. Placing the focal point onto one of the 'eyes' will be both successful and comfortable.

L'ESCARGOT
pastel on paper,
41 × 51 cm (16 × 20 in)

Although the shell looks fairly central, in fact I placed it carefully within the rectangle so that its sharply sunlit right-hand edge, and its shadow, were positioned in the lower right focal area of the rectangle. The flowers, in reality, were a different colour – I chose to use orange, the complementary colour to the blue-greys of the iron shell.

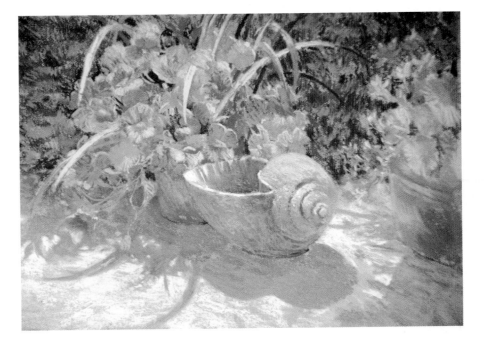

THE HURVA SQUARE CAFÉ, JERUSALEM

pastel on paper,

51 × 61 cm (20 × 24 in)

This was a difficult composition, since the café seats stretched across the scene, but I decided on a dominant focal area of the bench, table, silhouetted figures and two umbrellas on the left. The umbrellas are sharply defined by the light area behind. The lines of paving, and the tree trunk, lead to the focal point, about one third into the picture.

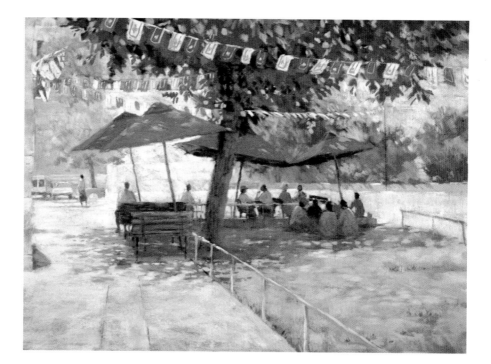

HOW TO EMPHASIZE THE FOCAL POINT

Deciding where to put the focal point is just the beginning. Although this will help you to begin your picture with confidence, since everything else should slot happily into place around the focal point, sometimes that focal point fails to attract attention. There are several devices you can use to ensure that the focal point commands the viewer's attention properly:

Strong contrasts of tone: If you place your lightest light area in the picture next to your darkest dark area, this will inevitably command attention, since this will be an area of great visual tension and drama – just what you want.

Strong contrasts of colour: By placing vivid complementary colours next to each other – blue next to orange, red next to green, or yellow next to purple – you will draw the viewer's eye to this point in the picture. If you use colour contrasts to draw attention to a focal point, the colours you use must be in key with the rest of the picture, so that they do not jump out in isolation, and should be gently echoed in other areas.

Dominant shape: A main, large shape in the picture will command attention – but be sure to integrate this shape with the rest of the composition, by echoing it with less dominant but similar shapes elsewhere, or perhaps by softening edges in places.

Direct the eye with 'lead-ins': Directional lines, implied lines, and points with an image can be used to gently lead the viewer to the focal point. For example, a pathway might lead up to a group of figures; the light-touched tops of clouds might bring the eye down to an important tree in the middle distance. In a still life, the edge of a table, or frame of a picture on the wall in the background might direct the eye to the bowls and jugs on the table. Becoming aware of shapes, and edges, within a rectangle, instead of thinking solely about the physicality of the objects featuring in the scene, is a big mental step to take, but a vital one to encourage the development of your sense of design.

Using a viewfinder: You will find it really helpful to use a viewfinder. We tend to 'see' our subjects, particularly landscape subjects, landscape shape. Yet a tall focal point may be much better expressed in portrait format. Make thumbnail sketches of the view. Feel free to adjust elements within the scene, to emphasize or echo the focal point – you could shorten a tree, for instance, if it is exactly the same size as the church, your focal point.

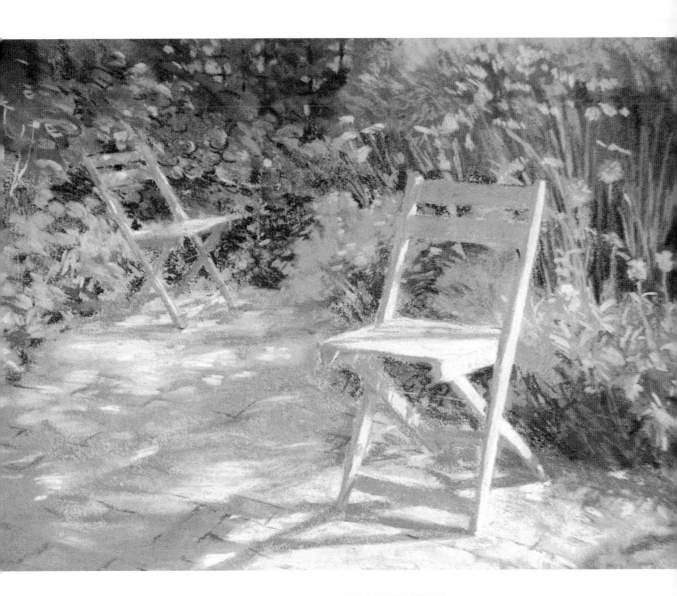

SUMMING UP

In his book *Composing your Paintings*, Bernard Dunstan says: 'It is dangerous, although tempting, to isolate the different aspects of painting from one another … everything in a picture that looks as if it could be taken out and examined as a subject by itself turns out to be dependant upon, and modified by, many other factors'. So although I have offered you a few basic ideas here about the focal point in relation to the composition of a picture, please be aware that it is only a small, if important, part of the whole painting.

TWO GARDEN CHAIRS
pastel on paper, 51 × 61 cm (20 × 24 in)

It is obvious that the foreground chair is the focal point of the picture. The shadows on the ground lead us in from the bottom edge of the rectangle to the chair, and the light tones of the chair contrast strongly with the dark surroundings. The second chair, repeating the angles of the first, provides an effective pictorial echo.

CREATING DEPTH

I have difficulty in creating a sense of depth in my paintings. How can I achieve the effect of depth so that they appear more realistic?

Answered by: **John Mitchell**

There are several ways in which you can suggest depth: perspective, tone, overlapping, and weight of texture or line. In practice any picture will use a combination of these.

Perspective is probably the most obvious way to suggest depth. Unfortunately, it can become confusing with expressions like 'vanishing points' and 'height lines'. So let us try to keep it simple.

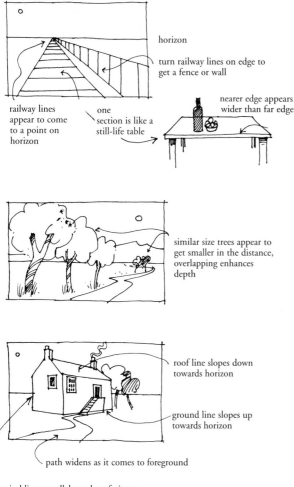

horizon

turn railway lines on edge to get a fence or wall

railway lines appear to come to a point on horizon

one section is like a still-life table

nearer edge appears wider than far edge

similar size trees appear to get smaller in the distance, overlapping enhances depth

roof line slopes down towards horizon

ground line slopes up towards horizon

path widens as it comes to foreground

vertical lines parallel to edge of picture

LINEAR PERSPECTIVE

Objects appear to get smaller as they get further back in the picture space. So a tree in the foreground will appear higher than a similar tree in the background. We all know about the effect of looking along straight railway lines as they run towards the horizon – they appear to come to a point. You can also get this effect by looking along the length of a table with your eyes at table height. Not only, therefore, do objects get shorter in the distance, they also appear to get narrower.

So far so good, but it gets a bit trickier with roof lines – how do we know when the line should run uphill or downhill? A common mistake is to make part of the drawing or painting look as if it has been seen from eye level and the rest from a helicopter. An obvious example is when a chimney top is drawn from above and the roof from below. Try to imagine yourself standing before the building. Draw the nearest corner, then if the roof line is above your eye level it will appear to run downhill away from you and the ground line will appear to run uphill. If you are drawing on site hold your pencil horizontally in front of one eye, against the building as it were – shut the other, and you will be able to see the correct angle very easily. If you are looking straight on at a building, the top and bottom lines will be parallel with the top and bottom of your page.

◄ *These drawings demonstrate easy approaches to perspective. Practise by drawing matchboxes seen from different angles and follow this up in thumbnail sketches like these. Perspective is the main method of getting depth into paintings.*

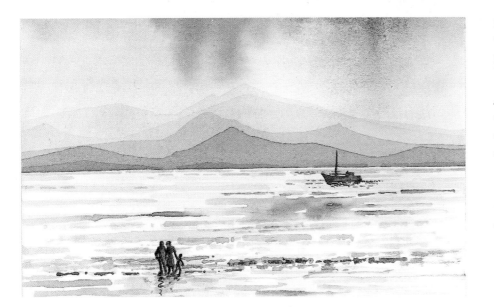

MOUNTAIN AND LOCH,
watercolour on thick cartridge
paper, 15 × 23 cm (6 × 9 in)

The mountains were painted in increasingly stronger washes of Indigo. The darker areas appear to advance and the lighter areas to recede. Strong tonal contrasts bring the boat and the people 'forward' to give depth.

AERIAL PERSPECTIVE

Aerial perspective means that tones and colours will become fainter in the background. We all know about the 'blueing' effect in distant hills where sky and land become almost indistinguishable.

TONE

Try painting a picture using one colour. Allow the nearer tones to become stronger by building up one wash on top of another and you will create depth. Strong tonal contrasts in foreground details will develop it further.

OVERLAPPING

If you draw objects separately across the picture surface, you will struggle to create the effect of depth. On the other hand, if you allow some objects to overlap others you will immediately suggest their spatial positions. Make the ones in front bigger and more tonally developed and depth will be reinforced.

WEIGHT OF LINE

Dark, strong lines drawn against a light background will advance into the foreground. So vary your linear quality to exploit this effect in drawings or paintings. It is really the converse of how white chalk works on a blackboard. The contrast between black and white makes the chalk legible, but try using white chalk on white paper and it becomes difficult to see.

similar size shapes strung out across picture give no indication of depth

different sizes can suggest depth

horizon line helps with depth

different sizes and overlapping create depth

simple perspective, overlapping and tonal contrast combine to create depth

Little exercises like these, using overlapping and tonal contrast can be done quickly. It is possible to create all kinds of depth effects using these elements. Invent your own wonderful landscapes and worlds by playing about with viewpoints and eye levels.

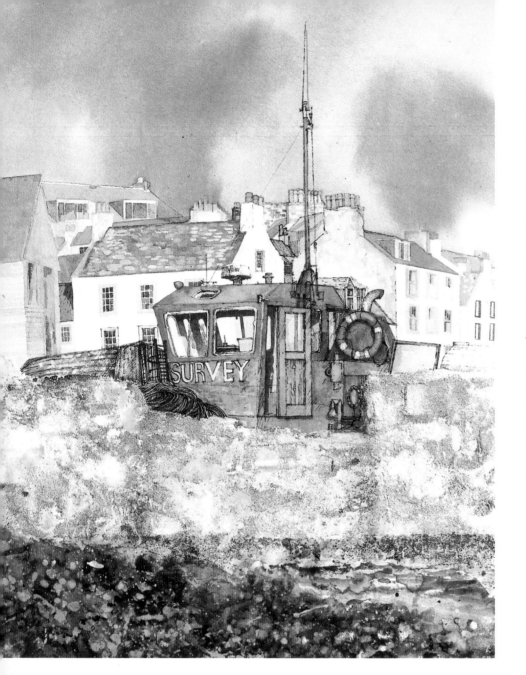

HARBOUR WALL
watercolour, pen and ink,
63 × 44 cm (25 × 17 in)

Linear perspective was used in the drawing of the houses and the boat's cabin. Notice that because the house tops are above us the roof lines slope down into the distance and we cannot see the top surfaces of the chimney supports. Aerial perspective has been suggested by using lighter tones and gentler contrasts in the background, saving the stronger effects for the middle and foregrounds. Overlapping was used extensively.

TEXTURE

Texture is a quality that can be so easily overlooked in painting. Try to develop your skill with it. Perhaps you could use thin washy paint layers in the background and thicker textural layers in the foreground. This is easier in oils or acrylics, but you can create varied textures in watercolours as well, by using dry brush, for example. Do not try using watercolour straight from the tube, however; it may crack as it dries. Respect your medium and work within its limitations.

Take one landscape or still-life subject and work it out in several versions using different depth techniques in each. Then try a combination of methods, in different proportions, to see which is most effective. These do not have to be 'finished' pieces; after all, you are hoping to learn from them. Quick, small studies are ideal.

Depth is something most of us try to achieve in our work. By experimenting with these techniques and exercises your skill will increase and your paintings improve.

SEVEN-MINUTE SKIES

Is there a quick and simple method of painting a sky in watercolour?

Answered by: **Winston Oh**

Have we not all had the experience of drawing a good landscape complete with fine architectural detail and then wrecking it immediately by messing up the sky? In order to succeed, it is important to pay attention to details such as your brush, paper, amount of water, paint, and speed of application.

Think of the sky as a loosening-up exercise. It is the least demanding component of your landscape. Unlike a building or other physical structures, you are not expected to paint the exact sky before you. Instead, you have the freedom to create the sky of your choice to suit the overall composition or the atmosphere you have chosen to depict.

Using the wet-on-wet technique is preferable because it results in a soft effect in cool colours, without hard edges, naturally contrasting with the stronger landscape tones and putting the clouds in the far distance where they belong.

INITIAL PREPARATION

For a support choose 200 gsm (140 lb) paper or more, as heavier weights do not cockle during the wet-on-wet exercise. A Rough or Not surface provides absorbency, which helps to produce soft fluffy clouds. A rougher surface makes it easier to leave random, irregular white unpainted accents on cloud edges, and facilitates the attractive flocculent textured effect of French Ultramarine when it dries.

Your brush has to be large enough to hold sufficient water. For a picture about 30 × 45 cm

BERNEY ARMS WINDMILL, NORFOLK

watercolour, 30 × 46 cm (12 × 18 in)

A grey, windy day, with low scudding clouds, enlivened by streaks of white paper showing through. This was painted with a large squirrel hair brush, in swift horizontal strokes, using various mixes of French Ultramarine and Burnt Umber. Payne's Grey was used for the heavy rain cloud. Th distant trees were painted with a mix of French Ultramarine and Indian Red.

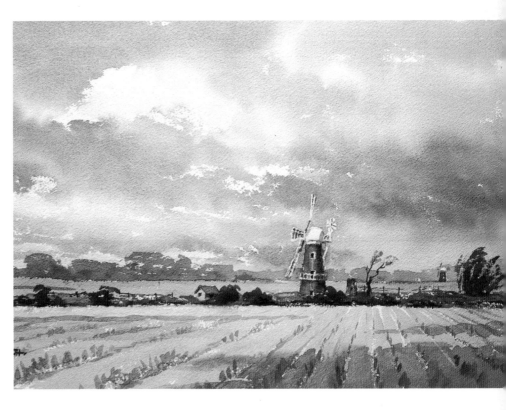

Step 1

Step 2

Step 1 *shows a soft grey sky, achieved with wet-on-wet technique.*
In Step 2 *brisker brushstrokes are added to produce a cloudy sky that is fresh and lively.*

(12 × 18 in) use a large squirrel hair brush, or a size 10 or 12 sable. On a picture 25 × 35 cm (10 × 14 in) use a size 9 or 10 brush.

For the purposes of the two demonstration pictures of a cloudy sky above, I used a combination of French Ultramarine and Burnt Umber predominantly. My other usual colours are Cobalt Blue, Coeruleum, Light Red and Raw Sienna. A blue sky may gradate from Ultramarine to Cobalt Blue to Coeruleum towards the horizon

as a result of refraction through the atmosphere. Often there is a warm glow just above the horizon, for which I use dilute Raw Sienna. Light Red is mixed with French Ultramarine or Cobalt Blue to create a cooler grey for distant clouds that are near the horizon.

Roughly plan where your cloud or clouds and darker tones are going to be placed, in relation to the rest of your composition. Indicate lightly with pencil the shape or rough outline of the cloud pattern. After gaining experience with this sky technique, it can be fun to improvise cloud formations without prior drawing.

THE WET-ON-WET METHOD

To start, angle the painting surface at 10 or 20 degrees. Wet the sky area fairly liberally and briskly with sweeping strokes. On rough surfaces this action will leave a few random irregular dry spots for accents. Unwanted spots can be covered over in the next stage. Leave larger dry irregular areas if you wish to create a prominent white cloud edge. Of course, you could wet the whole surface evenly for a soft fluffy cloud effect, as in Step 1.

Charge the brush with a moderate amount of a mixture of French Ultramarine and Burnt Umber of moderate intensity. More of one or other colour will determine how grey or bright a day you wish to portray. This is the base layer, so lay it on loosely in broad, preferably oblique, strokes, starting in one top corner. I use this as my tester corner. If the first stroke is too light, I can then stiffen the mixture immediately. I like a fairly strong toned corner anyway. As you move away from the corner, lighten the tone, varying the mixture with each brushload. If one corner is grey, make the other corner bluer. Where you wish to have white clouds, leave a gap of 2.5–5 cm (1–2 in) to allow for some diffusion of colour from the wet edges. Work your way down the sky, and by the bottom third dilute the grey towards the horizon, leaving it almost white around the middle third of the horizon.

Proceed immediately to the next stage (Step 2), where it gets more enjoyable. Use a significantly stiffer mixture of the same colours, with less water. This is important, because anything more dilute will make a mess and 'cauliflowers' may appear.

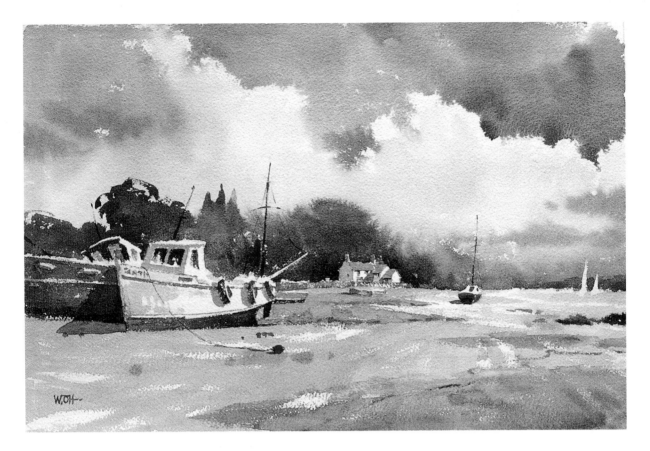

LOW TIDE AT PIN MILL, SUFFOLK
watercolour, 30 × 46 cm (12 × 18 in)

A sharp white cloud edge was obtained by keeping the upper cloud border dry while wetting the rest of the sky area. The contour was further shaped while working in a stiff wash of French Ultramarine. Light Red was mixed in for more interest in the sky.

Use this to darken clouds. As you move down the sky, narrow down the height of the clouds as they recede towards the horizon. Use Light Red mixed with French Ultramarine for the lower distant clouds with cooler tones. Do not forget to vary the size of the clouds.

Then, while the surface is still quite wet, you are ready for the final accents. Fill the tip of the brush with strong pure French Ultramarine and drop this into one or two small areas among the grey clouds to suggest blue sky peeping through. If you place the spot of blue beside a white cloud, it will accentuate the white edge immensely. Try washing in a dash of dilute Raw Sienna at the mid-horizon, behind a mountain or a pale area within a white cloud. You will be surprised at how this lifts the colour in the sky.

Now stop! Lay the painting flat and let it dry. Do not rework any part of the sky before it is completely dry. There is a cut-off point when the paper is about two-thirds dry, beyond which any application of paint will spoil it. Some accentuation can be done after drying. Wet the area first with clean water, and then drop in a darker, stiffer paint

lightly. This exercise should take you no more than ten minutes. I call it the 'seven-minute sky' simply to emphasize the key element of the technique – its swift application. A loosely painted, fresh-looking sky only works well while the surface of the paper remains fairly wet.

When the sky is dry, you will notice that the colours are about 10 or 25 per cent lighter. This may disappoint initially, but when the whole picture is completed, you will appreciate that the lighter sky contrasts well with the landscape below, and it recedes into the distance where it belongs. Practise and experiment with different colours and tones, and you will develop your own version of the seven-minute (more or less) sky!

THE LONGER VIEW

I always have problems with my foregrounds. Can you offer some help on how to tackle them successfully?

Answered by: **Jackie Simmonds**

Foregrounds can cause all sorts of problems. Too much detail, and the viewer's eye is held firmly in the foreground and fails to explore the rest of the picture. Too little attention to the foreground, however, may result in a boring, unconsidered area at the base of the picture. Often the main problem is that the student has not taken on board the idea that the foreground area of a painting has a purpose, and that purpose is usually – although there are no hard and fast rules in painting – to lead the viewer's eye into the scene. Even in the shallow space of a still life, or an intimate corner of a landscape, the foreground of the picture needs to be carefully considered.

ORGANIZING THE DIVISION OF SPACE

Before launching hell for leather into a painting, one of the best ways to prevent the foreground causing problems is to do a thumbnail sketch or two. I have lost count of the number of times I must have mentioned this, so forgive me if you are one of those who hates thumbnail sketches, and is fed up with being told that they are important. However, a small thumbnail sketch, executed in a few minutes, will quickly show you if your divisions of the rectangle are uncomfortable. You will be able to decide, before committing yourself to colour (and in watercolour painting, this is an extremely useful plus point),

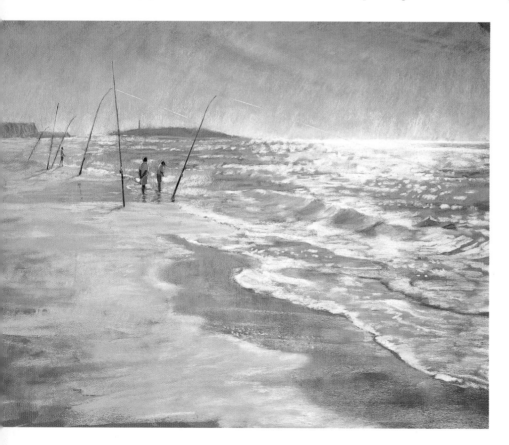

CAPE TRAFALGAR FISHERMEN

pastel on pastelcard,
46 × 66 cm (18 × 26 in)

I placed the horizon high in the rectangle to leave plenty of space for the foreground. In this way I was able to use the wave tops and edges, and the edge of wet sand, to draw the eye firmly towards the fishermen. A large foreground emphasized the emptiness of the beach, bar a few fishermen, and gave me the opportunity to paint the wonderful light on the sea, which was as important an element as any other in the picture.

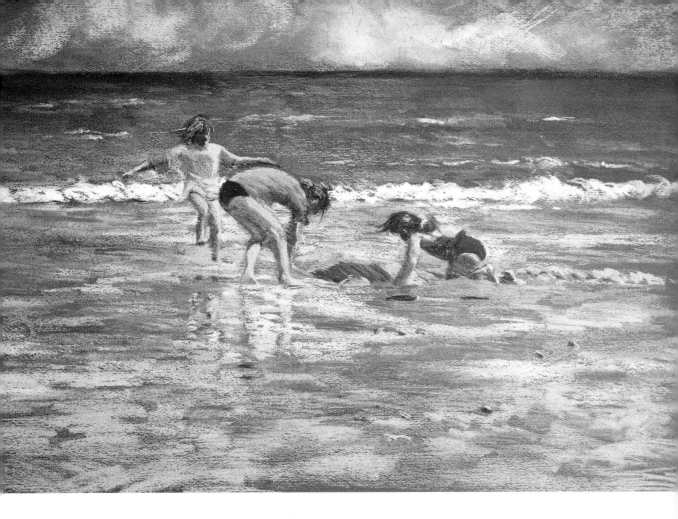

whether you have left too much or too little space for the foreground. You can change elements of the scene, in order to direct the eye more positively to the main centre of interest. You can decide whether you want foreground elements to dominate your picture – or whether they need to be drastically subdued. Making fundamental changes of this sort once a picture is well under way is not conducive to good temper!

A thumbnail sketch will sharpen your perception; you begin to see the subject through a painter's eyes and in pictorial terms. Clarifying your mind, and attempting to create a well-balanced design, does not mean that the image is set in stone – it simply means that you will be able to work more freely with your chosen medium, concentrating on the creation of an image that is a combination of good design and painterly approach.

KEEP IT SIMPLE

A very useful way to think about how to tackle areas of foreground is to consider the way we 'see' a scene at first glance. When we look at an area of landscape our attention usually focuses on a main point of interest –

SISTERS IN THE SANDS

pastel on paper, 46 × 66 cm (18 × 26 in)

This painting is composed of horizontal bands of colour, and the foreground area between the base of the picture and the focal point of the three children was quite deep and so potentially tricky – it could have been rather bland and boring. However, I emphasized the undulations in the sand, and the areas of blue, to break up the foreground in a lively and interesting way. Marks in the foreground are much larger than those in the distance, too, helping the sense of depth.

that which attracts us most. We are aware of the foreground – the area between our feet, and this point of interest – but only peripherally. So, somehow, we have to find a subtle way of painting the foreground so that it leads us to the point of interest, but does not detract from it.

A particularly useful aide-mémoire, therefore, is KIS – Keep It Simple. The danger, when sitting in front of a subject, is that we look too hard, and long, at the foreground, because of its proximity.

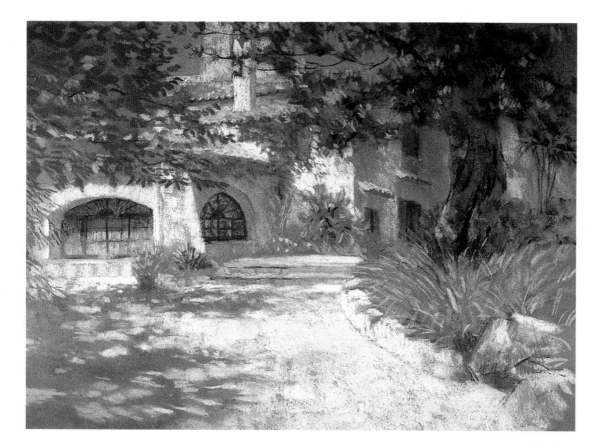

THE OLD MILL HOUSE, MAJORCA
pastel on board, 46 × 66 cm (18 × 26 in)

The foreground in this instance was an area of fairly colourless gravel – but once again, the sunlight came to my aid, and presented me with some wonderful shadows to use. Cover the shadows with a finger to see how important they are. Without them, the foreground would have been a large, featureless, uninteresting shape at the base of the picture.

Areas of foliage, for instance, can be very complex indeed, and if they are portrayed very precisely they will hold the eye firmly in the foreground, preventing any movement 'back' into the scene. It is generally a good idea to keep most foregrounds fairly simple – which may mean forcing yourself to find a way of simplifying what you see. Squinting at the scene often helps. Having said this, there is another trap waiting for the unwary painter. If you make the foreground too simple it might look empty and monotonous. A painter's life is not easy!

A FEW DOS AND DON'TS

● If your area of foreground is a large expanse of ground – for instance a field, or an area of grass, or sandy beach – while Keeping It Simple, DO see if you can vary the colours, and perhaps the tones, for variety and interest.

● In order to encourage a feeling of recession in the image DO see whether you can use larger brush or pastel marks in the foreground, and allow your marks to become smaller and finer as the scene recedes. This will create a good illusion of moving from foreground, to middle ground, to distance.

● DON'T block the viewer's 'path' back into the picture with a monotonous horizontal foreground feature, such as a fence, a wall, or a line of tall grasses across the bottom of the picture like a fringe.

● Obvious 'linear' landscape features such as paths, rivers or furrows can be used to lead the viewer's eye to the main point of interest, but DON'T FORGET that you can deliberately use shadows on the ground, subtle modulations of colour and tone, and suggestions of texture, for the same purpose.

● DON'T simplify the foreground to such an extent that it becomes a featureless bland shape at the base of the picture.

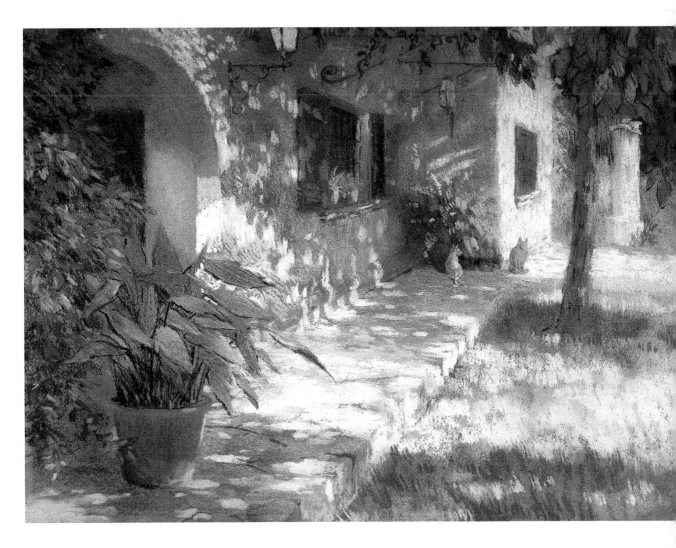

GARDEN SHADOWS, C'AN GAURI
pastel on board, 46 × 66 cm (18 × 26 in)

In this picture the eye is led towards the background, despite the important foreground element of a large potted plant on the left. The reason that the plant does not hold the viewer in the foreground is that the ground shadows link with the plant. The close tones in this foreground area hold together well, allowing the eye to move back gently, not only via the linear element of the path, but also across the bands of light and shade, which diminish gradually in size.

● Where possible, DO see if you can create subtle 'zig-zags' back into the distance – diagonal movements towards the background move the viewer gently backwards, encouraging a look around along the way!

Try to think of your foreground as a challenge – the challenge is to make the foreground an interesting and useful area, without necessarily including every element of detail visible in nature. You are an artist, not a photographer, so you can edit the foreground, and impose your will, and creativity, on the scene.

Pictures speak louder than words, so have a look at some of my paintings reproduced on these pages. Although I seldom tackle traditional landscapes with obvious foreground, middle and distance, I have included a few images that demonstrate the principles I have discussed here. Notice particularly how light and shadows can often provide strong directional elements to help your compositions.

FLORAL STILL LIFES

The flowers in my still lifes seem to lack life. How can I make them look really lush and thriving?

Answered by: **John Lidzey**

Flowers in a still-life setting can present the painter with an exciting prospect. They can offer a range of beautiful, delicate colours and tones, and graceful shapes that can be a joy to paint. However, often what looks attractive to the eye can be very difficult to represent in paint. The following guidelines will hopefully be of some help in the production of floral still lifes, where freshness and vitality are more important than botanical accuracy.

CHOICE OF FLOWERS

It is probably better to paint from real flowers rather than artificial ones. Although artificial flowers can be very realistic they often have a static quality that can all too easily be transferred to the painting. To overcome this problem, use a free and loose painting technique that will supply a quality of life missing in the subject, as in *Studio Window in Sunlight*.

Even if you choose real flowers to work from, avoid those that have a motionless elegance, which when represented in paintings can often look unexciting. It is better to select flowers that are rather more unpretentious with an interesting mixture of blossom and foliage. Wild flowers thrust roughly into a container can create a wonderful subject. But they may last for little longer than a day, so you may have to paint faster than you usually do before the subject wilts.

Match the container to the type of flowers you are painting. A simple, undecorated white vase may

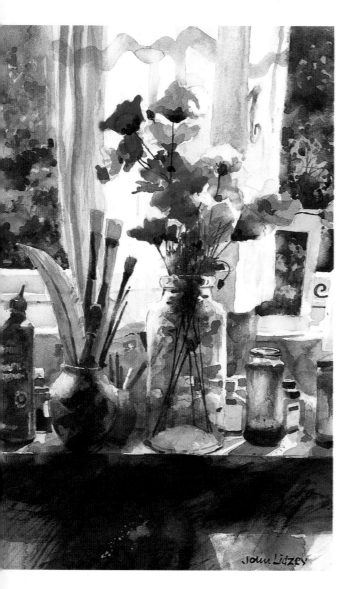

STUDIO WINDOW IN SUNLIGHT
watercolour, 43 × 28 cm (17 × 11 in)

The centrepiece of this studio still life is a bunch of poppies thrust into a glass jar. The flowers are artificial, yet the looseness in the way in which they were painted gives them a vitality that was missing in the subject. I allowed the colours to 'bleed' here and there and created a wide range of tones from pale tints to warm blacks.

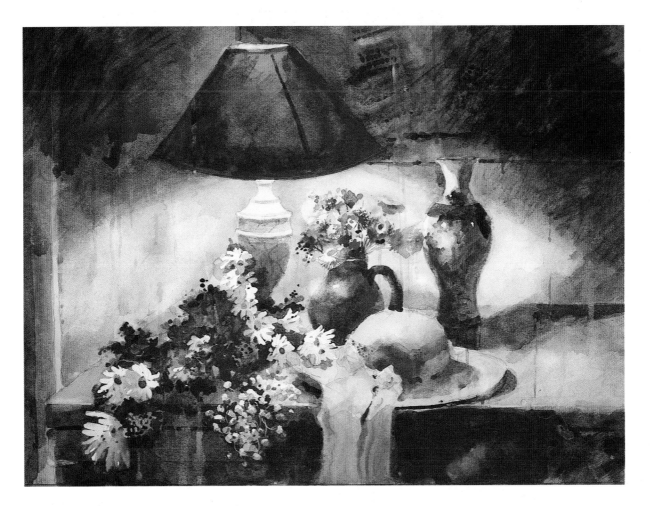

be all you need. Avoid ornate vases that might compete with your arrangement. Wild flowers in a jam jar can make a lovely subject that can be a joy to paint.

COMPOSITION AND LIGHT

It is possible to achieve good paintings of a few flowers or even single blooms, but for real life and vibrancy create a mixed arrangement showing plenty of flowers and foliage with good tonal contrasts. Even overcrowd the container slightly to create a sense of abundance.

THE SETTING

It may be useful sometimes to introduce other items into the composition. Bottles, jugs, jars, clocks or other similar objects make good accompaniments to a vase of flowers. But make sure that the arrangement does not become cluttered. Also, consider carefully the site for your still life. Window sills can be a good place to arrange your

FLOWERS AND HAT IN LAMPLIGHT
watercolour, 36 × 46 cm (14 × 18 in)

The flowers in this painting are mainly daisies with some dried flowers in a jug. Flowers lit by artificial light can be an interesting subject to paint. The daisies were partly painted with white gouache, while the dried flowers were reserved out of the background colour and then freely painted in with tints and darker colours.

set-up. In most cases the light from a window will provide interesting areas of tone, and if you are painting against the light the flowers will have added luminosity, especially if the blossom has a translucent quality.

Consider also artificial light from an anglepoise lamp to give a strong effect of light and shade. Providing strong illumination from one side will create a good three-dimensional quality that will help you when you come to paint.

◀ **WATERING CAN OF FLOWERS**

watercolour,

28 × 23 cm (11 × 9 in)

Flowers and greenery gathered from field and garden were jammed into an old watering can. I departed from the subject by painting in extra foliage and flowers to create a lushness of growth.

▶ **FLOWERS IN A GLASS JAR**

watercolour,

48 × 30 cm (19 × 12 in)

A mixed collection of flowers given a soft treatment. Surrounding tones were kept dark. To isolate the subject from the background the clock and glass jar were painted with hard-edged detail, thus creating a contrast with the loosely painted flowers.

METHOD OF WORKING

Many botanical painters and illustrators use a magnifying glass or microscope to identify minute detail in their subject, but the floral still-life painter can afford to be – or even should be – less fastidious.

Drawing: The initial drawing can define general masses of flower and foliage. Avoid getting involved in detail. A laborious drawing can easily lead to an awkward, stilted painting. If you wish to draw details, save these for any other artefacts that might also be part of your painting.

Painting: A useful way of working is to create soft edges to flower forms. If using watercolour, slightly blur edges by smudging them with a finger or cotton wool. Doing this will usually give a sense of movement to the picture, contributing to an organic quality in the subject. As the painting progresses, see how much detail you can leave out rather than include, while still retaining the form and shape of what you are painting. This approach will allow the viewer to participate more actively in the interpretation process.

Foliage can be painted without showing full detail. Use wet-in-wet techniques to soften leaf outlines. Organic qualities can often come about by creating loose and runny paint. Flick or drop paint in a random fashion over flowers and foliage to generate a sense of spontaneity. You can also use an

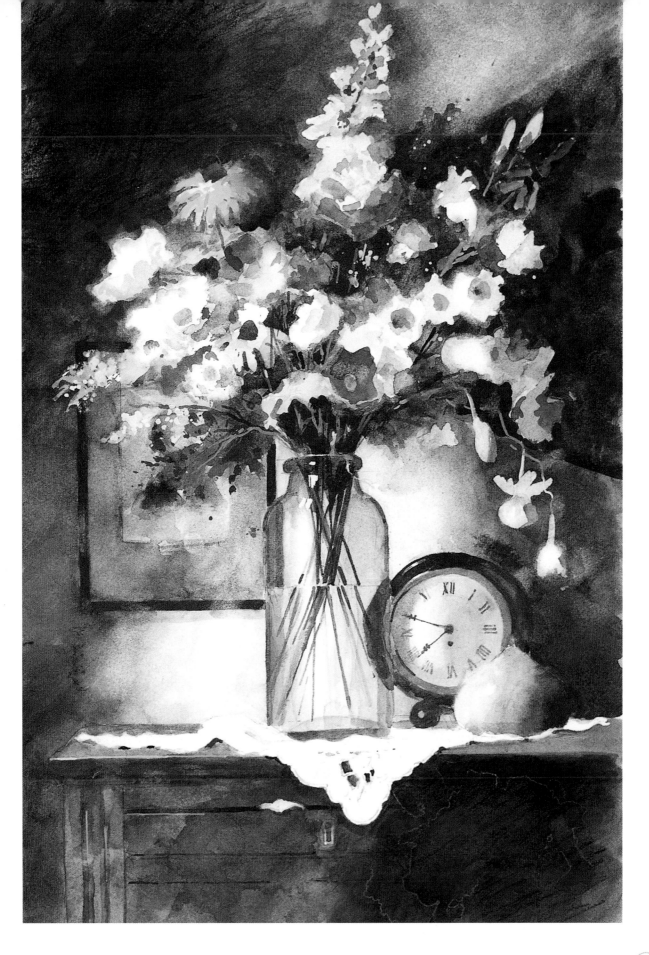

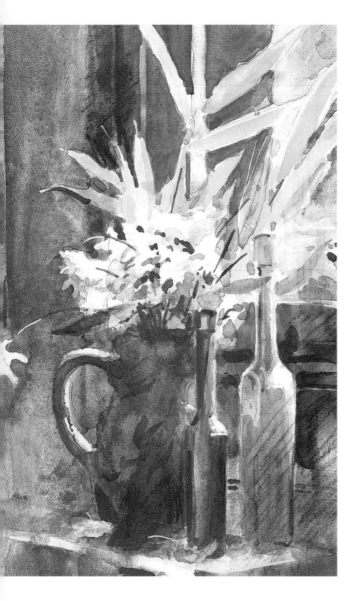

SNOWDROPS AND BAMBOO
watercolour, 41 × 28 cm (16 × 11 in)

I made no attempt here to define the snowdrops. One or two dots of paint and a few pencil marks suggest some detail. First, I painted dark tones round the leaves, leaving them white, then I freely brushed in various green hues over the unpainted spaces. The bottles, jug and window frame were kept quite dark to make the leaves and flowers seem to radiate light.

old toothbrush to spray paint, or drop paint on the subject from your paint brush.

While a free painting technique can be very effective it is important that you maintain control. So do not overdo your random paint effects. Mix rather more carefully painted flowers with looser ones to create variable definition.

Improvisation: When painting flower still lifes consider the value of improvisation. Be prepared to depart from your subject matter in the interest of producing better work. If necessary, add more flowers to your composition than are actually there, or increase their size slightly. If the foliage lacks density, fill it out. Slavishly painting what you see is not always the best thing to do. As Degas suggested, if necessary lie a little.

Colours: Avoid overmixing colours, especially when painting flowers, and keep your colours clean. If using watercolour, make sure that your water is not dirty. An effective flower painting can result from a good contrast between clean, pale tints and strong, low tones.

You will not necessarily need lots of colours for this kind of work. For the paintings shown here I used the following colours: French Ultramarine, Monestial Blue, Indigo, Payne's Grey, Cadmium Scarlet, Cadmium Red, Carmine, Aureolin, Cadmium Yellow Pale, Cadmium Yellow Deep, Yellow Ochre and Cobalt Turquoise, together with a tube of Permanent White gouache, useful for adding highlights and some white flowers.

It is probably best to mix greens rather than use them directly from the tube. Pure, proprietary greens often have a powerful, intense quality that can look totally unnatural. The colours recommended above can provide a satisfying range of yellow/greens through to cool blue/greens.

Masking fluid: Sometimes masking fluid is useful for isolating pale flowers from surrounding dark tones. But whenever you think you can avoid its use, do so. A more free, loose quality results from reserving (painting round) such areas. It is often better to paint pale flowers into dark tones using white gouache mixed with an appropriate watercolour hue.

Flicked paint and loose
washes of colour

No real
definition in
the leaves

Daisies roughly
indicated with
white gouache

Flowers show
no real
detailing

Flowers shown as
silhouetted shapes

FLORAL SKETCH
watercolour, 20 × 18 cm (8 × 7 in)

*The use of a free painting technique can create a sense
of movement and life in flower sketches.*

BRUSHES

The use of very small brushes with fine points can
create bitty, fiddly marks that can lead to awkward
flower paintings. It is often the case that slightly
worn larger brushes without sharp endings can be
better for painting. Certainly, if using watercolour,
make your smallest a No. 4 round brush for
detailed work, a 16 mm mop brush for washes and
a No. 8 round brush for filling in.

PAPER

The best watercolour paper to use for floral still-life
paintings is a fairly well-sized, smooth-surfaced
grade, not less than 300 gsm (140 lb). A quarter
sheet, measuring 38 × 28 cm (15 × 11 in), is the
very smallest you should use, but working to an
even larger dimension can be a good idea. Working
on a full-size sheet of 56 × 76 cm (22 × 30 in)
would be really adventurous.

SENSE OF MOVEMENT

How can I convey movement in my paintings of wildlife?

Answered by: **Peter Partington**

The idea of movement in painting is a paradox because the image, once completed, is of course resolutely static. It is the eye that moves over, about and 'into' what is always a flat surface. This movement of the eye communicates itself to the brain, fools it into perception, and the mind into meaning. Our eyes follow the direction of brushstrokes, for instance, or a linear curve around a body or tree, and stop to pause over enjoyable colour and texture.

A masterpiece will command our eye movements and thus our attention until its message in colour, line, tone and proportion sinks in.

COMPOSITION

Achieving this sense of movement derives from the core of composition and does not cease until the last tickle of brushwork completes the piece. In pursuing my own genre, wildlife in landscape, the two belong together. Often landscape provides inspiration as light moves across it, but I also perceive an underlying 'sense of movement' in, say, inanimate boulders, trees, or mountain vistas. The surge of a mountainside or swing of a tree trunk demands that it be analyzed and savoured. On fortunate occasions an animal or bird may appear simultaneously to add another dimension, their own life and rhythm, to their habitat, providing a unity of movement, mood and perception.

SQUARE COW, COOL COW
pencil and watercolour, 12 × 8 cm (4¾ × 3¼ in)

A quick block shape is adequate to set the scene for a distant cowscape, but further inquiries suggest the shape consists of subtle curves. It is these curves that give life to such a subject.

REAL MOVEMENT

Capturing living and mobile nature is more demanding as I try to give the illusion of real movement against a 'moving' background. There are quick ways of introducing animals into the landscape. I sometimes suggest to students that they block in cows in a fieldscape with simple square shapes, which are good enough for distant vistas. But if we look further into the cow's shape we find more subtle lines like the shallow 's' along its back as shown below. Instantly the animal becomes more 'alive'. This 's' line is akin to 'the line of beauty' eulogized by Hogarth: a harmonic of two curves, one long, one short. It is to be found in many birds with long necks like cranes or swans.

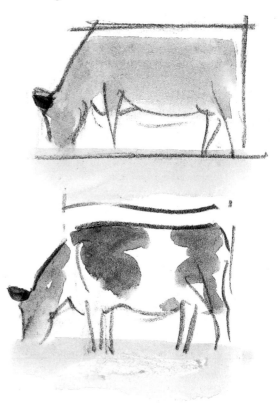

CURVES AND WAVE FORMS

An important variation on this is revealed in the neck of the heron *(right)*. This consists not of the simple shape found in the swan, but a dynamic broken 's' shape. This bird has a special vertebra in its neck that allows it to click forward to spear fish at lightning speed. It is an exciting disharmony, a break for the eye before completing the next curve. Such curves are to be found throughout the animal and physical world and contribute much to the exciting interplay of muscle, limb and bone that makes for dazzling displays of kinetics.

The heron's neck is a wave form – lay it out horizontally and you have the basis for a sea-song of gull and breaker *(right)*. Use the curve to plan your composition. The choices for placing a single bird against such a line are infinite. My personal choice is to place the bird as if toppling over the crest, suggesting both fulfilment and potential.

Zooming in, we need to study the gull itself: the tear-drop shape of the aerodynamic body, the tilt of wing, the rhythms of features and foreshortened wings. Sketching from life will familiarize you with the bird's attitudes. Practice will allow you to master the movement from ground to subject, from surging swell to air-flung gull, to 'become' the gull. By imaginatively identifying yourself with your subject – its rhythms, its life – you will find a unity of expression that will transfer itself to the paint through the brushwork.

▼ **HERON AND SWAN STUDIES**
pencil and watercolour, 5 × 8 cm (3¼ × 2 in)

The slow 's' shape of the swan's neck contrasts with the heron's dynamic broken 's'. The eye halts along the 'heron line' a–b, pauses and then glides quickly along the remaining distance. The 'swan line' c–d is less dramatic. The heron's neck contracts into a spiral.

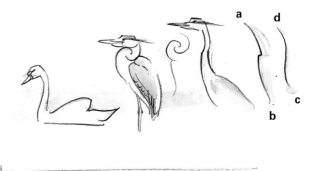

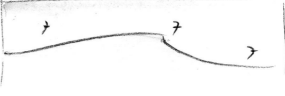

▲ **GULLS AND WAVE FORM**
pencil and watercolour, 5 × 14 cm (2 × 5½ in)

Broken harmonic of the 'heron's neck' laid flat. Lay your fingers over any two gulls to find the position you prefer, for build-up, crescendo or finale. The curve could also work well for eagles against a mountain top.

STUDY FOR GULLS
pencil and watercolour,
8 × 8 cm (3¼ × 3¼ in)

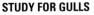

Familiarize yourself with the shapes of your subject by studying the original. This will enable your gestures to flow with knowledge and freedom. The side-view of the gull at the centre shows the rhythm formed by foreshortening along the wings. On the approach the gull at bottom right shows the offside wing in advance of its shape. In retreat the gull's nearside wing is ahead. Head-on the profile shows the wing's long harmonic 's' shapes. A slight turn of the head in the top gull changes the mood entirely.

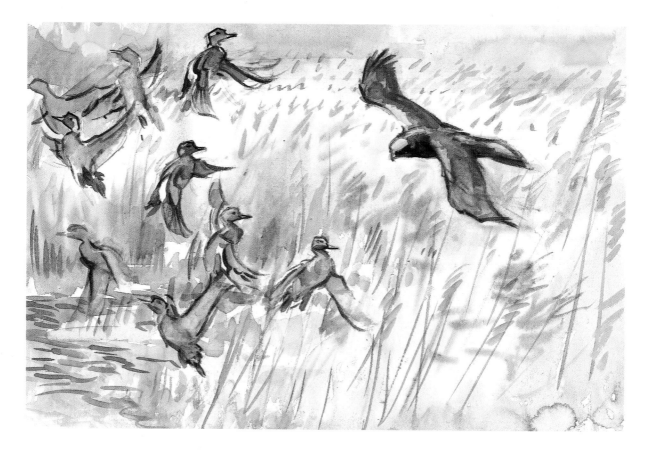

▲ MARSH HARRIER SURPRISING GADWALL
watercolour, 56 × 76 cm (22 × 30 in)

The theme of this study is dramatic, but I wanted a sense of exuberance that accompanies wind and sunshine amongst the reed-beds. The reed-heads gave me the opportunity for lively mark-making. The ducks are decidedly unfinished, which also contributes to the blur of action as the group explodes outwards.

▶ MARSH HARRIER SURPRISING TEAL
pencil and watercolour, 30 × 23 cm (12 × 9 in)

The high skyline in this portrait-format study forces our gaze down and emphasizes the plunging harrier. Much study of exciting wing-patterns was necessary as a preliminary. Cutting out the wing-shapes in paper and looking at them from various angles is a useful ploy for understanding them.

Where the bird in question is a power-flyer rather than a wind-rider, dynamics emerge from thrashing pinions and air pressure. Powerful flight muscles provide the wild duck with the power to take off vertically and to stay up.

PRELIMINARY SKETCHES
In my watercolour study *Marsh Harrier Surprising Gadwall* I have attempted to express the panic among the ducks at the sudden arrival of the raptor. The ducks' shapes are thrown down in an exploding bunch bursting up and out, contrasting with the long-winged glider. Obviously a painting like this demands many preliminary sketches. In this study

the reed-heads and stalks offered opportunities for lively brushwork, adding life and vitality to the picture surface. The straight horizon line provides a stability in all the action. The ducks are in the foreground and our sympathies lie with them as they frantically try to fly away.

A second study on the same theme, *Marsh Harrier Surprising Teal*, allows us to look over the shoulder of the bird of prey. The movement is 'into' the frame rather than 'out' as in the first study. We also identify with the plunging hawk rather than the ducks. The portrait format adds the potential for a dive down in contrast to the desperate verticals of the teals' take-off.

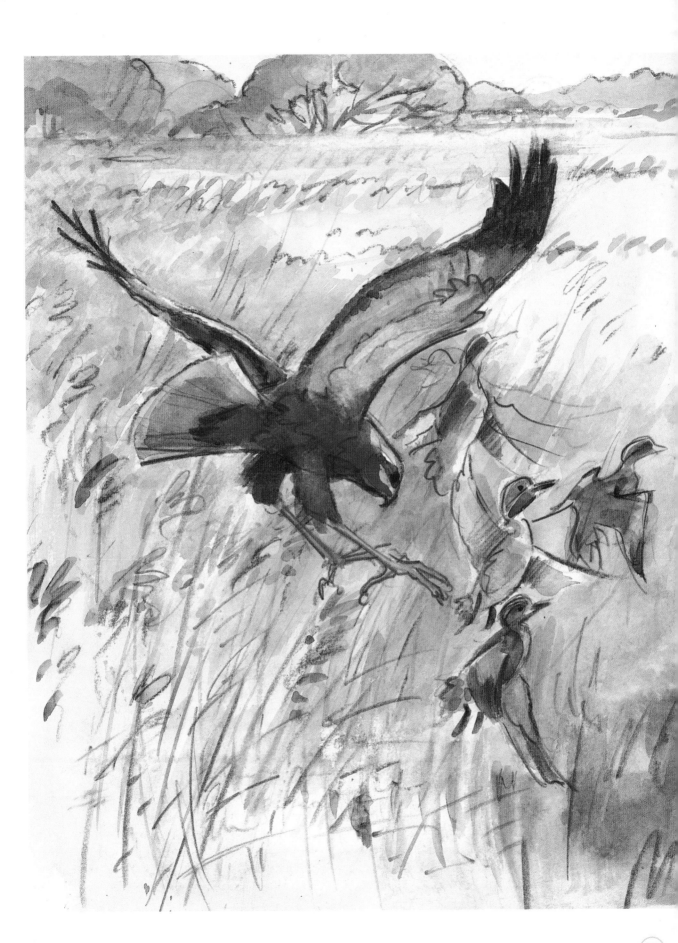

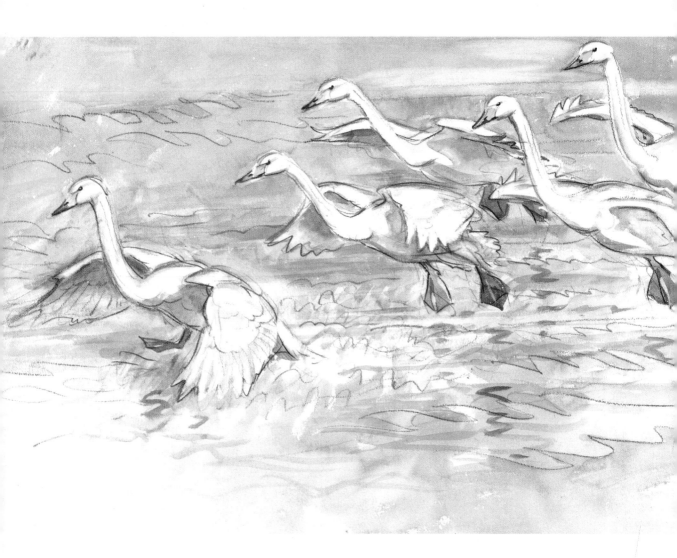

USING PHOTOGRAPHS AND VIDEO

I sometimes pursue a theme obsessionally. A subject is rarely exhausted with one picture. *Whooper Swans Alighting* is one such theme. I returned again and again to draw at the Wildfowl at Wetlands Trust Reserve at Welney in Cambridgeshire to marvel at the spectacle of the wintering wild swans. Photographs are useful, and I also studied video-footage frame by frame until I felt I knew exactly what feather does what as the swans cruise in to splash down. Such study awaits the time when the information is so much part of you that the painting can be put down with all the life and vitality that your feelings about the bird can inspire.

I have not finalized the idea, which could be played with further or transferred to a canvas and taken further with oils. Bear in mind, however, the more detailed a picture the more danger there is of it becoming static.

WHOOPER SWANS ALIGHTING
pencil and watercolour, 56 × 76 cm (22 × 30 in)

In this study I attempted to capture the cascading effect – the tip-toe feeling of momentum and yet braking to land. Obviously the forms of the swans themselves embody this feeling and I have used appropriate rhythms and lines to emphasize this. I drew the birds on the spot – at Welney in winter – where families continually arrive from the fields to feed. I studied video of swans landing and I use photographs for information. This study could be developed to any degree of finish.

8 CLUES & ILLUSIONS

I struggle to suggest any sense of space in my paintings. How can I get it right?

Answered by: **Richard Pikesley**

Take a sheet of paper and draw a horizontal line, or divide it into two horizontal bands of colour, and your eye will try to read the 'image' as a depiction of landscape. Your eye is surprisingly eager to read flat surfaces as if they are three dimensional, and this can be used to your advantage.

There is no single 'thing' called space that you can put into a painting. Rather, the feeling of depth comes from placing a lot of clues that add up to a sense of space. When it is done well, the eye fleshes out these few clues and is happy to be convinced that the world continues beyond the confines of the frame. Most of the fundamental elements to do with creating an illusion of space are equally applicable, whatever the medium.

CHOOSING A VIEWPOINT
Working with inexperienced painters I am often struck by how difficult they find it to make foregrounds big enough, yet a bit of careful

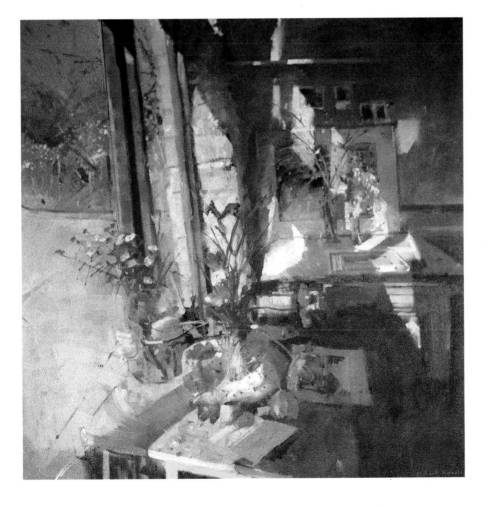

MAY AFTERNOON, BOTHENHAMPTON

oil, 91 × 91 cm (36 × 36 in)

This was painted standing on a box, partly directly and partly from small studies. I wanted the feeling of strong light slanting into the studio, and the sensation of looking down. A feeling of outside and inside was important, and the whole composition had to be carefully drawn first and attacked at some speed to try to capture the fleeting geometry of those patches of light.

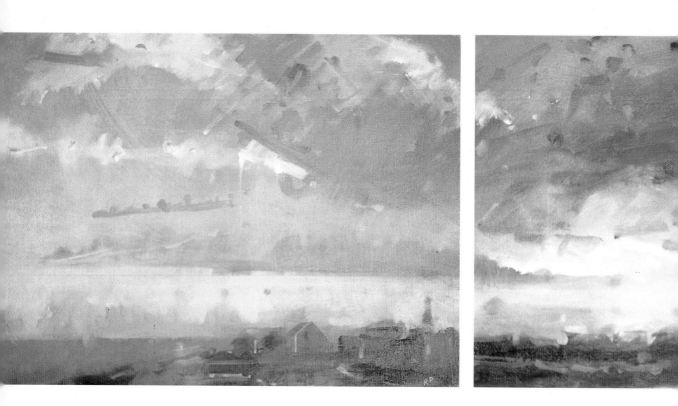

PORTLAND TRIPTYCH
oil, each image 30 × 41 cm (12 × 16 in)

This wide-angle view was painted across three panels. Wide shallow compositions can easily become a bit frieze like and flat, but the diagonal of the cloud masses sweeping back into the picture allowed me to maintain a feeling of space.

measurement will soon have them progressing confidently and getting on with the painting. You have to realize that your brain is constantly trying to tell you that the scale of things remains constant, and yet your eye knows best. Your brain will mislead you into reducing the size of foreground objects, and inflating the background. By pushing the foreground back and pulling the horizon towards you, everything ends up in the middle distance, the presence of the picture plane is accentuated and distance denied.

Glancing out of my window, I notice how a raindrop on the glass close to my eye neatly covers a large tree in the distance. Now this obviously brings in the 'P' word, but without any detailed knowledge of perspective you can get a long way by just letting your eye outrank your brain! For instance, consider including more 'floor' or more

'roof' than you otherwise might. These will help in connecting the more distant part of the painting with the viewer's own space. Remember, too, that the sky is as much roof as it is backdrop, and by including more 'floor' the viewer is encouraged to walk into the picture in their imagination.

It can be tempting to try to organize your viewpoint so that each element of a composition is fully visible within a painting. Yet as soon as one object partly obscures another you know which one is in front and a bit more space is opened up, the overlapping forms taking you back step-wise into pictorial space. The great masters of the Japanese woodcut print knew this and relied on it heavily in the absence of formalized perspective. As an exercise, you might try drawing any view in which elements overlap, allowing yourself only line, and concentrating on how one contour is broken by the one in front.

All of the above may be helped by choosing your viewpoint with real care. When you are painting a landscape, try to find somewhere to stand where you have an element of the view large and close to you rather than in the middle of acres of 'empty' grass. If you are painting in a jumbly interior, take advantage of all of those overlapping shapes to carry the viewer's eye back into the pictorial space of your

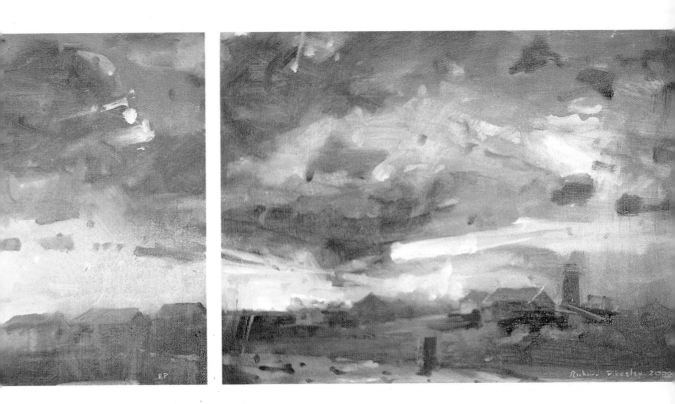

subject. If you find it difficult to 'see' a composition, a simple viewfinder will help you to isolate a view. Making little exploratory drawings before starting to paint will also help.

TONE AND COLOUR

Often, especially in landscape subjects, foregrounds contain darker tones and more contrast than levels further back, which close in towards grey.

When I was a student I remember being told to look harder and I can clearly remember screwing up my eyes, and my determination to see what was going on. I now know that was a real hindrance, and what I should have done was to relax my gaze to take in more of the view, and to be aware of the little tonal steps in the context of the big ones. It is about allowing yourself to see. Look hard at the horizon on a misty day and you will convince yourself that it represents quite a big tonal jump. Relax your eye to take in a wide angle and the varied tones of the whole scene and you will see this tiny step for what it is. As with linear drawing, by establishing the big framework first, everything else should fit into place.

Although it is a bit of an old chestnut that warm colours advance and cool ones recede and must not be taken too literally, there is more than a grain of

oil, 91 × 76 cm (36 × 30 in)

The perspective of the shadows of the window frame, the strongly lit foreground and transparent dark beyond help to give this subject a sense of space.

◀ **TULIPS (AND PASSING CHICKENS)**
oil, 76 × 61 cm (30 × 24 in)

Painted looking through the studio window, the chickens in the yard beyond were a constant distraction. The background is painted rather thinly and I enjoyed painting the hens tangled up with the reflections of the tulips in the window. Scale, overlapping and alternating bands of light and dark help to spell out the spatial relationships in this potentially rather confusing subject.

▶ **BIG EVENING SKY, WEST BAY**
oil, 76 × 91cm (30 × 36 in)

I have painted from this viewpoint quite often and it can be tricky as the strong horizontals of the pier right in the foreground tend to flatten out the sense of space beyond. Once again the sky comes to the rescue with the layered effect of dark on light together with the aerial perspective of the successive headlands defining the spatial recession.

truth in the idea. Red light gets filtered out quickly by atmosphere so the further you go back the more blue bias is apparent. But there are many exceptions: you need to think only of a brilliant sunset sky with cool foreground shadows. But generally it pays to be aware that this blue/grey shift as you go back in space can be quite marked. To find the right colour for that red tractor on the distant hillside may take you a long way from Cadmium Scarlet.

PAINT SURFACES
Strong outlines and lots of edges will tend to emphasize the picture plane rather than depth within the image. Heavy impasto will also tend to draw attention to itself rather than what it depicts. Conversely thin, translucent paint tends to recede. It is not uncommon to find painters using energetic, edgy brush strokes in the foreground of a painting and quieter washes in the background. Be aware, though, that this can become a bit of a formula and done to excess looks very mannered.

We are not necessarily talking about enormous depths back to a distant horizon. Many of these comments apply just as much to interiors or still-life subjects where the depth represented by the

painting may be just a few metres, or even centimetres. For many of the great Baroque painters, from Caravaggio to Rembrandt, this limited, enclosed space was used to great dramatic effect when combined with strong light and shade and a single light source. The painting, through the window of its frame, became a view into another room in which extraordinary things were happening. These painters knew that, by restricting the depth they chose to depict, the three-dimensional effect they could create would be all the more compelling.

BE CONSISTENT
The spatial sense of a painting is closely bound up with when it was painted. There is a wholeness to the feeling of light and space at any one time and it can change quite fast. If you work all day on a sunlit subject the direction of light changes radically and spatial clues provided by the direction and perspective of cast shadows painted at various times will tend to cancel each other out. More subtle than that is the feeling of the same quality of light falling throughout a subject.

Working quickly can be at least a partial solution, trying to get everything done before too

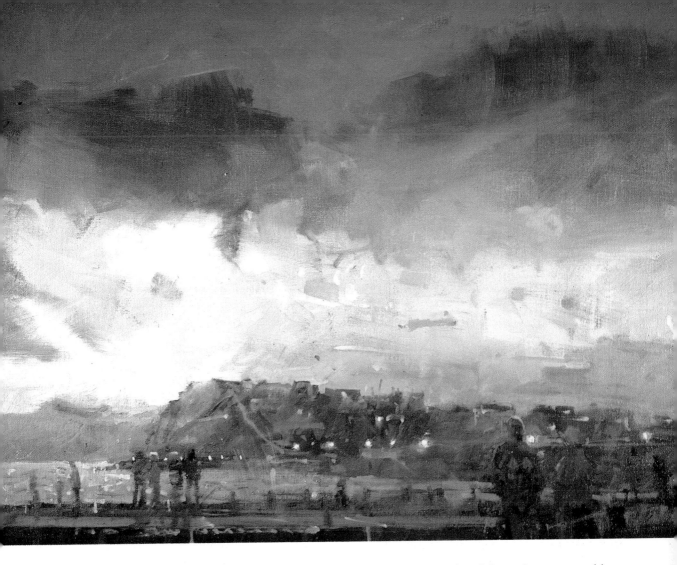

much has changed. Your working time can be extended by sorting out the drawing before the time when the light effect becomes critical, and by working for a short period each day over a number of days. Otherwise, be prepared to re-state everything as the scene changes, and work no bigger than the largest size on which you can quickly revise the whole painting.

Be on the look out for signs of perspective in natural subjects. Such things as the lines of waves or ripples on a sandy beach, clouds and cast shadows can often be used to lead the viewer's eye back through the painting. Diagonals that go obliquely back into the picture plane, and long lazy zigzags are particularly suggestive of depth.

THE BIG PICTURE

It is important to keep a grip on the whole painting. This can be easy early on, working fast with big brushes. Later on, however, it is easy to become preoccupied with lots of separate problems. If you sense that this is happening, try to see the whole composition and work at pulling the whole thing together.

Now this should not be too self-conscious or artificial a process. With increasing fluency and confidence all of the above 'bits' become one seamless whole. In varied painting situations different aspects of creating space have the leading role. Painting landscape, atmospheric qualities of tone and colour are likely to predominate, whereas painting still life or interiors, the more drawing-based aspects are likely to have more importance. In each case, however, the successful depiction of space comes from the cumulative effect of all of these qualities. Sometimes a painting can be really rather slight and yet very evocative of airy space so it is not a question of having to dot every 'i' and cross every 't', but if what is done is painted with real visual understanding the illusion will be convincing.

TONAL STRENGTH

I have been told that the biggest weakness in my paintings is that they lack tonal strength. Can you help?

Answered by: **John Mitchell**

Tonal strength is the skeleton of the picture around which colour can provide the flesh. Most of the paintings I see when I visit exhibitions by art societies are watercolours and the common weakness is their lack of tonal strength, which makes them look pale and insipid. The first step to solving this problem is to think of tone as running from a scale of one to ten, with one being the lightest and ten the darkest. I find that many paintings tend to settle around the range from four to seven and ignore the more contrasting tones like, for example, one or nine.

You might be tempted to think that all you have to do to develop tone is either to add white to get light tones and black to get dark tones. Of course you could do this, but you may well end up with rather dead colour. When working in watercolours I rarely use white paint but rely on transparent washes, and the paper, to create the lighter areas. With oils and acrylics the danger of using only white to create light tones is that it can

It is important to have tonal contrast in a painting. If nearly all the tones are selected from the middle sections of the scale the picture will look flat. Two thirds of the picture area light and one third dark, or the converse, will be much more interesting. Touches of the lightest or darkest tones will add 'punch'.

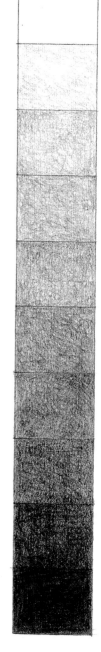

Try creating dark colours without using black. Time spent on producing charts like this is well worth while. Make sure you label your mixtures as I have done here. File your charts for reference.

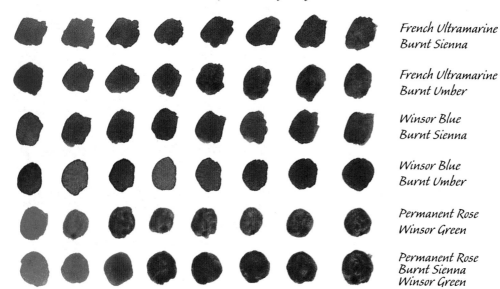

*French Ultramarine
Burnt Sienna*

*French Ultramarine
Burnt Umber*

*Winsor Blue
Burnt Sienna*

*Winsor Blue
Burnt Umber*

*Permanent Rose
Winsor Green*

*Permanent Rose
Burnt Sienna
Winsor Green*

 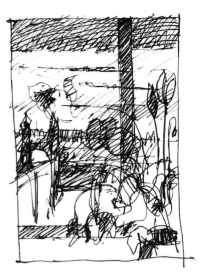

produce chalky colour. Try adding a lighter version of the colour you are trying to mix. For example, if you want a light yellow colour, add a little lemon yellow into the mixture along with white.

What is the point of trying to mix dark colours without using black? Although black has its place on the palette I believe that you can mix much more interesting dark tones without it. Construct a colour/tone chart using a couple of blues and mixing them with Burnt Sienna and Burnt Umber. Try adding Winsor Green or Permanent Rose to these mixtures and see what happens. Keep this chart and refer to it whenever you need to mix dark tones. These mixtures will be much more vibrant than straight mixtures with black and will even appear darker.

Most artists make one or two colour sketches before beginning their main work. Why not make a few tonal sketches as well? Consider whether you are trying to produce a dark painting with a limited light area, or a light picture with a limited dark area, or any other combination. Important details like these should be worked out in advance in small sketches, and kept beside you as you paint.

To emphasize tonal strength avoid having equal areas of light and dark, and as a general rule avoid putting your strongest contrasting tone right in the middle of the composition.

The tone of the painting will relate closely to the kind of mood or subject you want to express. The same composition painted in different tonal ranges will express different emotions. Dark, moody, smouldering tones will create a different effect from light, sparkling tones.

Uni-ball (Royal Sovereign) pen on Daler 150 gsm (70 lb) cartridge paper. Small sketches make it very easy to try out different tonal arrangements before committing yourself to the final work. Think of the broad effect rather than detail, working quickly and freely.

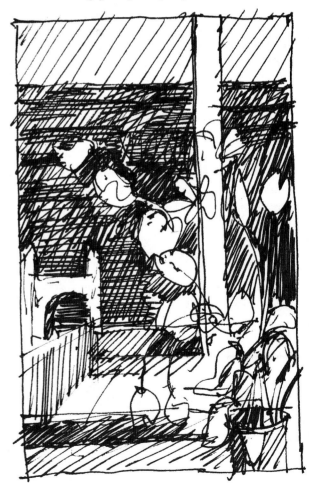

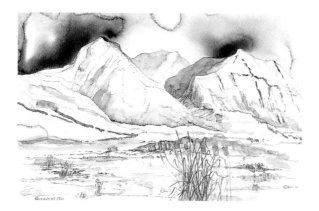

A monochrome exercise using Indigo. The intention was to explore the subject, taken from a sketchbook study made on site, using a wide tonal range. Using only one colour encourages this. Sepia is another pigment that is useful for this kind of exercise.

▼ **TOWARDS COIRE BA, NOVEMBER**
watercolour, 19 × 30 cm (7½ × 12 in)

A colour version of the study above. The intention was to retain the full tonal range of the monochrome sketch, and a tracing was made to try to replicate the original composition. The sky was washed in with a mixture of Winsor Blue and Burnt Sienna for a rich dark tone. The mountains were painted in transparent mixtures of Winsor Blue, Permanent Rose, Raw Sienna. The richer tints in the foreground used Cadmium Red and Cadmium Yellow.

A useful exercise is to do a monochrome painting using a wide tonal range, then repeat it using a full palette trying to retain the tone effects from the first version. Another interesting exercise is to paint two versions of the same composition, with one reversing the tonal values.

Make a point of looking at works by artists who make use of strong tonal structure. Rembrandt, for example, was a master of light and dark. Do not just study his paintings. Examine different versions of some of his etchings, which demonstrate how he experimented with light and shade. Look also at the different approaches to tone by Impressionist masters like Monet and Pissarro. Monet's work is apparently formless at times, Pissarro's has a more pronounced dark 'skeleton' around which he hung touches of colour.

Tonal structure is an important formal element in any painting. If it is given the same importance as other formal elements like drawing and colour your work will become much stronger.

▶ **STUDIO WINDOW**
watercolour on Daler Langton paper, 28 × 19 cm (11 × 7½ in)

Based on a sketchbook study, this composition was developed in monochrome, using Indigo, with the aim of creating as wide a tonal range as possible. When the Indigo was dry a few of the lighter areas were given washes of Alizarin Crimson and Cadmium Yellow.

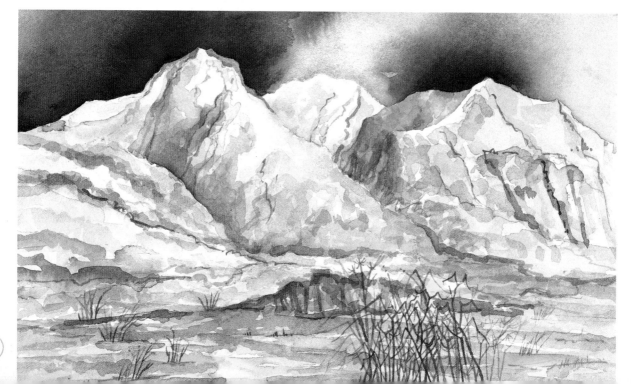

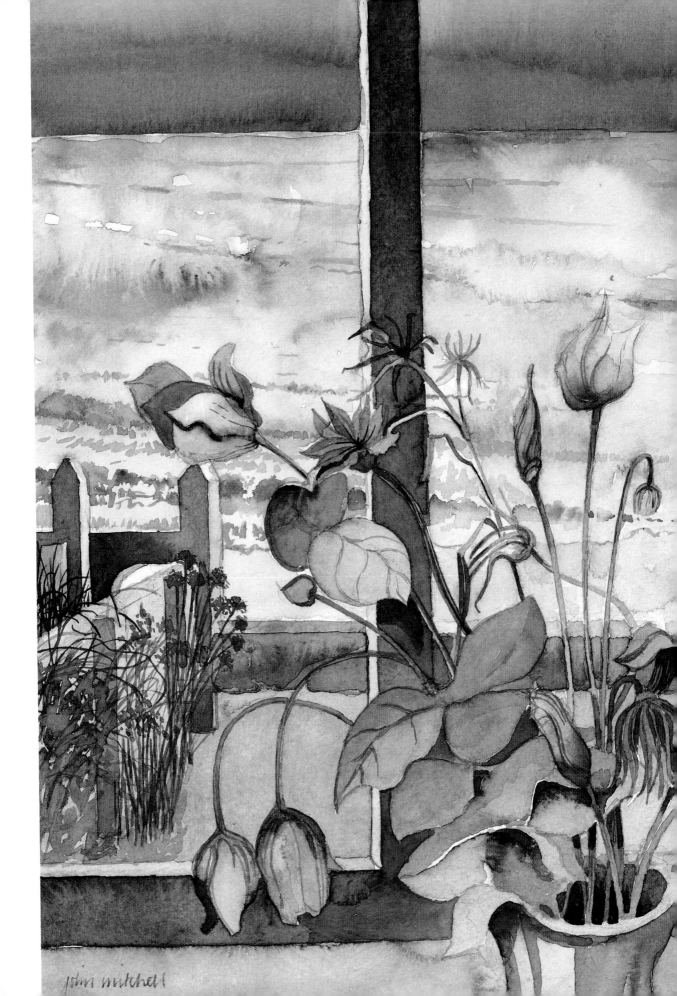

john mitchell

SOFT GARDEN COLOURS

How can I avoid garish greens and over-bright flowers in my garden paintings?

Answered by: **Jackie Simmonds**

A garden is most enjoyable to paint – but you have discovered that it is far from easy to achieve a truly satisfying result. At first glance, nature's greens and the flower colours are rich and vibrant. But if you use unmodified rich and vibrant colours throughout your picture the result can often be more than a little overwhelming.

To my mind, the most difficult garden colour to deal with is green, and the biggest mistake an artist can make is to use too many greens that are harsh and artificial – those sharp, turquoise-viridian greens, and brilliant emerald greens are wonderful in small doses, but they need to be used with care, in small quantities, and balanced with a range of 'softer' greens, and other colours in the foliage: blues, yellows and even pinks and reds. If you have a piece of turquoise-green fabric at home, or an emerald green object, hold it up at a window, with the garden behind. Compare the greens. You will immediately see what I mean. All the garden greens will look muted and grey-green by comparison.

I have used pastels for the pictures here – my favourite medium – but whatever medium you use, the same principles apply. If you use watercolours or oils you can mix colours to achieve these 'garden greens' – see opposite. The permutations are endless. In watercolours, too, the amount of water you add makes a big difference to the intensity of the colour. Just beware of Viridian. On its own, it is very strong, and staining – but it mixes well with other colours, and can be toned down by using red, its complementary colour, to create a range of muted greens. (Also try using Terre Verte, which is a lovely grey-green.) In both oils and watercolours,

SHADY PATIO

pastel on paper, 38 × 53 cm
(15 × 21 in)

Complementary colours and warm/cool contrasts are used throughout this image. Warm and cool greens dominate – yellowy greens for sunlit areas, and cool, bluer greens for areas in the shade. Red, green's complementary, is used in small areas, striking against all the greens. Cool, blue-grey shadows on the patio contrast with the warmth of the sunlit areas.

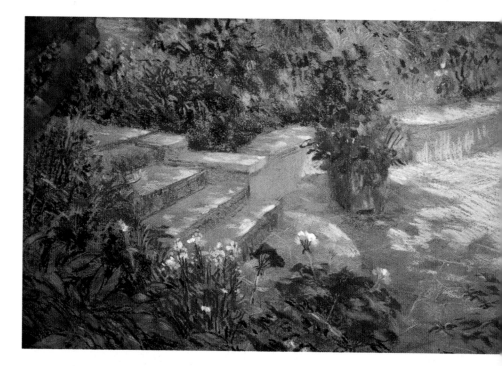

POSSIBLE MIXES FOR SOFTER GREENS

If you do not have all the colours mentioned and want to create a good range of greens from just blues and yellows, it is useful to know the following.

Some blues are green-blue, such as Coeruleum, and others move towards red on the colour wheel and become more purple-blue, such as Ultramarine. Similarly, yellows can be rich orangey yellows, such as Cadmium Yellow, or sharp greeny-yellows, such as Lemon Yellow.

If you mix a green-yellow with a green-blue, the result is likely to be a clear, bright green. However, if you mix orange-yellow with purple-blue, the resulting mixture, which contains hardly any green to begin with, will be quite dark, more 'grey', or even brownish. Good mid-greens, therefore, can be mixed by choosing your blues and yellows carefully, ensuring that there is a bias towards green in one or other.

OIL PAINTS

1. White, Coeruleum, Cadmium Yellow
2. Viridian, Cadmium Yellow
3. Viridian, Cadmium Yellow and White
4. Viridian, Cadmium Red and White
5. Cobalt Blue and Cadmium Yellow
6. Prussian Blue and Yellow Ochre
7. Oxide of Chromium, Cadmium Red and a touch of Viridian
8. Oxide of Chromium, Cadmium Red, Viridian and White
9. Viridian and Naples Yellow
10. Viridian, Naples Yellow and a touch of Cadmium Red

WATERCOLOURS

1. Viridian (from the tube, rather bright and unnatural)
2. Sap green (from the tube, a good yellow-green)
3. Viridian and Cadmium Red
4. Viridian and Alizarin Crimson (in equal quantities, makes grey)
5. Cobalt Blue and Cadmium Yellow
6. Yellow Ochre and Prussian Blue
7. Terre Verte, diluted and full strength
8. Sap Green and Alizarin Crimson
9. Hooker's Green Dark (from the tube – soft and natural)
10. Oxide of Chromium (from the tube – a soft grey-green)

OILS

WATERCOLOURS

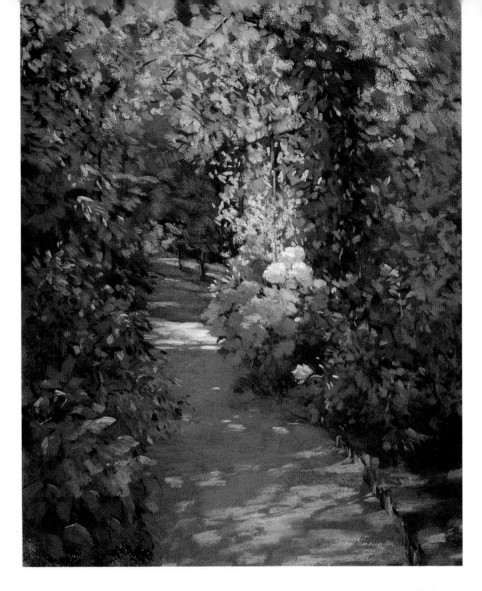

HYDRANGEA PATH
pastel on paper,
64 × 41 cm (25 × 16 in)

In this painting the foliage dominates the picture, and the flowers are subordinate. However, you can see that I have not used harsh, artificial greens, and as a result the overall effect is soft, and not at all garish.

it is helpful to remember that tube greens can be modified by adding a touch of complementary colour, but be careful, as too much red will neutralize the green.

For the pastel painter, there is a superb range of greens to buy, from every manufacturer – so many, it is difficult to select, and impossible for me to advise, except to say you should try to ensure that you have a good selection of tones in a range of cool and warm muted greens, as well as the richer, sharper greens.

FLOWERS

Flower colours are often strong and bright, and if I want my flower colours to dominate the picture, I need to think carefully, in advance, about the balance of flowers and greenery in the image. Fifty per cent brilliant green and 50 per cent brightly coloured flowers will mean that the greens and the

flower colours fight for attention. It is usually better to offset large areas of bright flower colours with smaller areas of muted greens.

It also helps to think about the colour bias of the picture. A riotous multi-coloured border does not necessarily provide good material for an effective picture – there may simply be too many colours there, and the picture will look harsh and discordant if you include all of them. I like to select an area of the garden where one colour dominates, and I arrange all the other colours in the picture to work with that main colour, using the basic principles of colour theory. This means that I will decide, in advance, whether to use colour harmony (colours side-by-side on the colour wheel) or complementary colours (allowing my main colour to dominate, and using its complementary pair, in muted form, elsewhere in the picture). Colour harmony is my favourite choice. Believe it or not, if

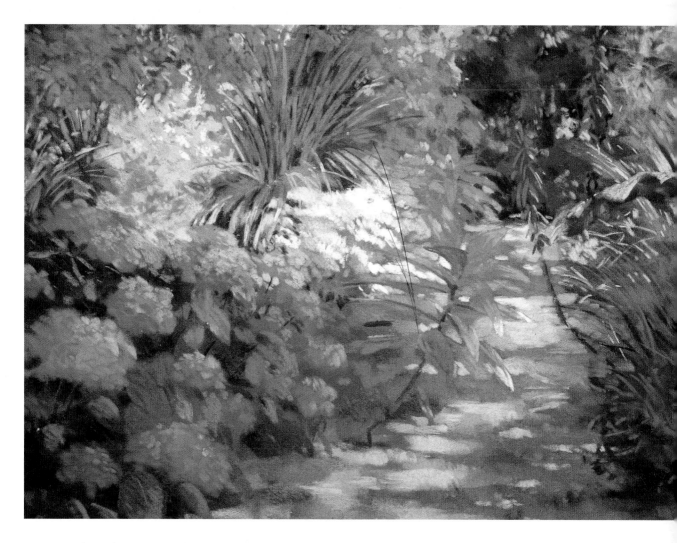

you use colour theory to guide your selection, even the most vivid flowers in a garden picture will look soft, natural and convincing. If all this thinking in advance sounds too structured, and too much like hard work – well, I make no apologies for this. If you want to create a successful picture, I believe you need to use your brain as well as your eye, your hand, and your emotions! If you do not know the colour wheel, I urge you to spend a useful hour one day studying the basics of colour theory. I can promise it will be time well spent.

Garden flowers often provide a colourful feast for the eye. Achieving a colour-filled garden image that is not garish is achievable with a little care where greens are concerned, some judicious planning, and a willingness to eliminate jarring colours, even if they are, actually, there in your garden scene. All you need now is some good weather to sit outside and paint.

SAUSMAREZ GARDENS, GUERNSEY
pastel on paper, 43 × 61 cm (17 × 24 in)

Hydrangeas again! I cannot resist them. This time, see how much blue I have used in the foliage. One way to achieve colour harmony in a picture is to repeat a colour wherever you can – it acts like a rhythmic 'echo' and enables the viewer's eye to move more easily and smoothly around the image. Subtle pinky-orange light on the ground provides a lovely complementary contrast, as do the touches of rich burnt orange nestling in amongst the blue flower heads.

PAINTING SKIES

Is it better to paint skies on location or to paint them working from a photograph?

Answered by: **John Lidzey**

You stand before a beautiful view with a half-completed landscape. Storm clouds are gathering, rain is possible and it is certainly becoming more windy. The scene is majestic and very paintable. Should you paint the sky from nature or capture it on film and paint it at home in comfort with the knowledge that a photographic reference is both secure and permanent? It is certainly worth considering both options.

WORKING ON LOCATION

What might be said about painting a sky from the subject is that a sense of involvement comes about in the process of working. You become in effect a physical part of what is being painted. For example,

to be buffeted by the wind when painting a squally sky means that more than the visual sense is engaged in the work. Often it can mean that if the conditions are poor and you have difficulties in working, the resulting painting is a success not in spite of the weather but because of it. Sometimes paint or even drops of rain falling on wet pigment can provide extra immediacy to the work.

Stormy skies painted on location can make wonderful paintings, but, as just suggested, conditions can often cause problems. Watercolour paints seldom dry quickly enough and paper is blown about. The oil painter's easel can lack stability; not to mention all the other problems that low temperatures, wind and wet can bring about.

OLD COTTAGE, SUFFOLK
watercolour, 30 × 42 cm
(12 × 16½ in)

This painting is based on sketches made on location. The hazy atmosphere hints at a change in the weather. The complete sky was painted wet-in-wet, the clouds blotted out with damp cotton wool. When dry, Carmine and various yellows were added (top left and centre). The French Ultramarine on the left was deepened with a wash of Indigo, and Payne's Grey reinforced the clouds on the right.

STORMY EVENING AHEAD

watercolour, 17 × 25 cm
(6½ × 10 in)

This study was quickly made late one day in winter. The clouds seemed to be rather hard edged, so I made extensive use of the wet-on-dry technique. In an attempt to keep up with the quickly changing conditions I used some rubbing out and repainting. The trees were painted back in the studio in the dry! Colours used were: Indigo, Payne's Grey, Cadmium Yellow Pale, Scarlet Vermilion, Monestial Blue.

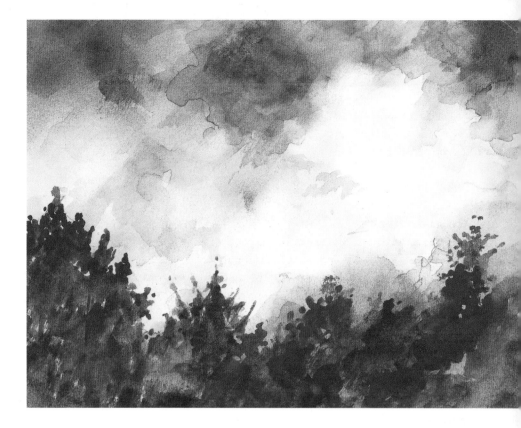

It is often better to sketch in poor conditions rather than produce any finished piece. Working with watercolour is probably the best option. The composition of the sky, its colours and tonal values can be recorded quickly and (with practice) easily. A good small sketchbook can be enough to get down the general quality of most skies, ignoring fine detail, just looking for the overall shape of what is there. All that is needed is to make a few pencil guidelines and then lay in first washes. Following this, darker areas can be painted wet-in-wet and wet-on-dry with more concentrated paint.

Clear skies can be good to paint on location and they can often accompany comfortable working conditions. When painting such skies look carefully

▼ *A small sketchbook can be useful for making visual notes of sky conditions. This one shows white cumulus cloud set against darker, thicker cloud (on the left). It is a good idea to make notes about colours used for the sketch, but other information could also be added, time of day and temperature, perhaps, and even the direction of the wind and its speed.*

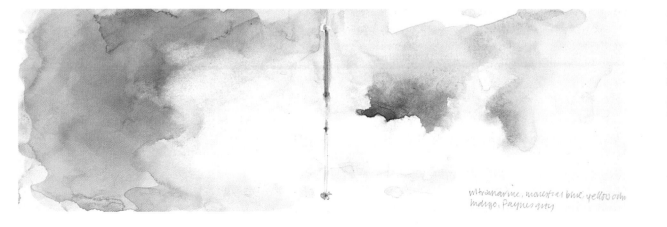

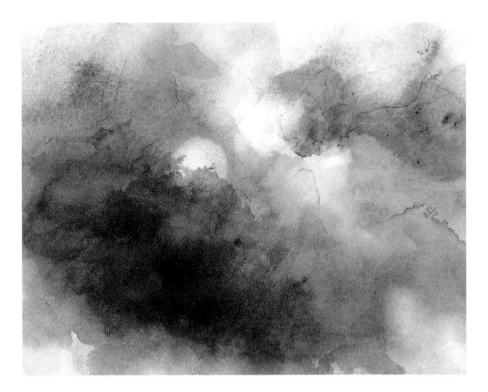

In this experimental study I laid down French Ultramarine and, while the paint was wet, I dropped in stronger mixes of the colour and then blotted other parts out with cotton wool. When this was dry I painted the clouds with mixes from Cadmium Red, Yellow Ochre and Indigo followed by the same techniques I used for painting the sky. The sun was wiped out of the cloud using a paper mask with a circular hole cut in it.

at the changes in tone and colour, possibly deep blue high up, gradating down to a lighter, more ochre, colour at the horizon. In order to create an interesting painted surface the oil painter can consider textured or scumbled surface effects, while the watercolourist can use uneven, overlaid washes of colour. The important point is to avoid absolutely flat colours, which can often look completely unnatural.

Many summer skies present marvellous cumulus cloud effects. These skies are often in a state of rapid change, so it can be possible for you to finish a sky that is totally different from the one seen at the start. In these circumstances it can be a good idea, early in the painting, to establish the sky's composition and build up the values as the painting progresses. For the watercolourist a good sky colour can be created with French Ultramarine mixed with a small amount of Yellow Ochre. Depending on conditions other pigments can also provide useful sky colours: Cobalt Blue, Coeruleum or Monestial Blue. Additionally, rather than painting round cloud shapes it is often a good idea to blot them out with damp cotton wool, but only do this when the paint is freshly laid. Producing simple cloud and sky experiments on a regular basis can develop your ability to make really interesting outdoor paintings.

USING PHOTOGRAPHY

Another possible way of working can be to paint your chosen subject on location and then paint a sky at home using a photograph. The obvious advantage of using a photographic reference is that the subject is static. It could be argued that this is the best possible way to paint an absolutely authentic sky. You can carefully define the shape and position of clouds and a careful study of the effect of light, colour and tone can be made; all of this can be done at leisure.

The problem is that when painting from a photograph too much information is available. You will find yourself drawn to the detail as if by a magnet. Trying to record every nuance of cloud shape will give a stilted look to the finished result. In fact the sky may end up looking like a painted photograph rather than a painting. One possible way of overcoming the temptation to add excessive detail is to make a black and white photocopy of your photographic reference, and perhaps even make a photocopy of the photocopy. This will give you the overall shape of a cloud formation and simplify details and tonal values.

For the watercolourist a non-absorbent watercolour paper is best, not less than 300 gsm (140 lb). It is important for the paper to be

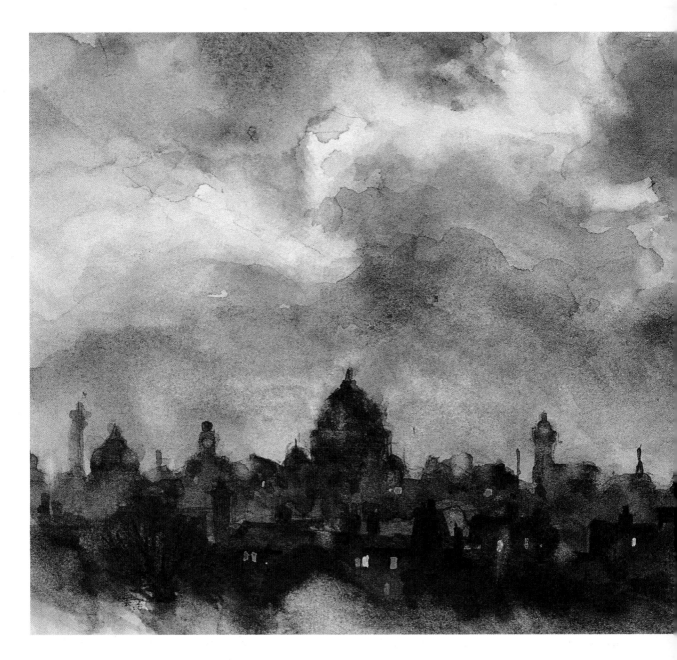

properly stretched. Painting skies often involves covering large areas of paper with wet paint. Stretched paper will be less liable to cockle, making paint much easier to control.

Begin the sky with a simple drawing of the cloud shapes, leaving out intricate photographic detail. Make sure that you have properly prepared your painting materials before working and ensure that your palettes and water are clean. Have some 18 mm (¾ in) and 12 mm (½ in) mop brushes to hand and kitchen towels or cotton wool for mopping out colour. Begin the painting with flat washes showing the underlying sky colours. When they are dry,

A CITY AT DUSK
watercolour, 13 × 17 cm (5 × 6½ in)

The buildings in this watercolour are in silhouette and give an effect of twilight. The sky was based on a photograph taken at midday. In this case the buildings and sky might be judged as working well together, possibly because the grey base clouds are quite low in tone. Much of the detail in the photograph has been excluded, but the general shape of the sky has been retained. A loose wet-in-wet technique was used to avoid a harsh effect.

cloud shapes can be built up wet-on-dry with a brush not much smaller than a (round) No. 8. Use your photography as a guide only. Let the paint flow and allow for the possibility of accidental effects occurring. Doing this will help you impart a spontaneous quality to the work. Match the sky with your terrestrial subject matter. Note the direction of light and ensure that it is the same as the light at ground level; ensure also that the weather conditions at both levels are the same.

CREATING A SKY

On dull or completely cloudless days, rather than working from the subject or from a photograph, an alternative is to paint a sky out of your own imagination and experience. Many painters do this on location and the results are often very effective. Quite minimal effects can be suggested, even if only a vaguely defined bank of clouds on the horizon. More ambitious effects, however, can be achieved with greater daring.

Dramatic cloud and lighting effects are best worked out in the studio or at home. Working this way it is possible to do tests and studies before a final commitment is made to the finished painting. It is important, however, to make sure that your landscape and sky are compatible with one another,

ON WALBERSWICK BEACH
watercolour, 11 × 25 cm (4½ × 10 in)

This quick small painting was made on a stormy day, using a wet-on-dry technique with no blotting out. The sky was much greyer than shown here. The colours used were French Ultramarine, Monestial Blue, Aureolin, Yellow Ochre, Indigo and Cadmium Yellow Pale. With these colours it is possible to suggest a grey stormy sky while achieving a colourful result.

but even here it is worth experimenting. Sometimes a sunny sky and a low-toned, shadowless terrain can look very effective and be surprisingly realistic.

Consider making small paintings of imaginary skies – just for your own interest. In some cases you may be able to adapt one of these skies for use with a landscape painted on location. The result might be quite wonderful. However, if you want to work successfully out of your imagination it is important that you build up your knowledge of what skies in all conditions look like. The best way to do this is to sketch regularly. Work quickly and freely to get down the essential characteristics of skies in all weathers and at all times of the day. Your results may at first be rough or incomplete but persevere and your paintings will improve.

VIEW FROM THE DELL
watercolour, 20 × 25 cm (8 × 10 in)

A fairly ordinary prospect is made more interesting with a dramatic sky. The clouds were invented on the spot, replacing the flat, featureless haze that existed at the time of painting. I gave the clouds a diagonal axis to contrast with the horizontals and verticals of the field edge, gate and gateposts. The blue sky is pure French Ultramarine. The dark clouds are Payne's Grey, Yellow Ochre and Cadmium Red.

12 FIGURES IN PAINTINGS

How can I produce convincing figures and most effectively introduce them into my paintings?

Answered by: **Gerald Green**

Introducing incidental figures into a painting can often add life and movement to what might otherwise remain a fairly static image. By devoting a short amount of time to studying figures separately, you can significantly improve your ability to depict them more convincingly.

Formal art training has always included working from the nude figure as a means of developing and refining observational skills. Compared to drawing elements from the landscape, for example, the subtle balances between the forms and contours of the human figure are far more elusive to detection by the untrained eye, yet, unless depicted accurately, will cause the figure to appear distorted or wooden. Attending a life class will offer a valuable opportunity to devote time to formal studies from the posed model, but everyday life can also offer numerous chances to draw figures. The

difference here is that temporary subjects rarely remain completely still for any length of time, so it is necessary to adopt a different approach.

FINDING SUITABLE SUBJECTS

To begin with the most suitable figures to work from can seen seated, either in cafés, restaurants, in parks or on the beach. The most static standing figures will probably be found chatting, in queues, or waiting for public transport. Start by making small line drawings, no more than about 5 cm (2 in) in size, in pencil, felt-tip pen or even ballpoint pen, if this is all you have to hand, concentrating on the overall outline shape of the figure. Do not worry about any details in faces, hands or feet.

These initial studies should be gestural drawings in which the aim is to portray the general posture and form of the figure, ideally with the minimum amount of drawing. Aim for quantity, since getting used to the act of observing and drawing is itself as important at this stage as the quality of the results produced. A useful option is to retain one sketchbook just for figure work from which you will then be able to judge your progress as you proceed. A pocket-sized pad 21 × 15 cm (8 × 6 in) is ideal; it can be used whenever a subject presents itself and it is small enough to enable you to work undetected by would-be onlookers.

Try not to become discouraged if at first your images appear laboured or unnatural. As with any learning process, making mistakes is a necessary part of the path towards improvement. As you become more proficient try making brush drawings in either watercolour, ink, or felt-tip brush pen. Concentrate on the overall shape and gesture of the figure without concern for detail, drawing the shape as a silhouette; again, it will be easier if you work

Typical small sketchbook page, 15 × 21 cm (6 × 8 in), showing a mixture of gestural figure drawings.

function that will be reflected in the gesture of the body movement, and the principal aim of any drawing should be to try to capture this underlying characteristic. A challenging test is to look only once at your chosen moving subject for a couple of seconds or so, in order to fix in your mind the essentials and then, without looking again, draw all that you can remember as quickly as you can. This is quite difficult at first, but working in this way will help you develop your visual memory.

If you can find a willing sitter, perhaps a friend or family member, then more elaborate concurrent studies can also be attempted, or if you possess a large enough mirror then you might like to try a full length self-portrait. With these more formal drawings you can take time to concentrate on the more problematical areas of faces, hands and feet.

If your results are becoming repetitive or you are getting lost in too much detail, try changing to a different medium – this will further broaden your experience. Try using charcoal, or combining ink or felt-tip pen line drawing with a watercolour wash, or pen line with pastel.

Experiment by making brush 'doodles' using watercolour. With a well-loaded brush, begin with a blob for the head and using sideways movements of the brush, dragging it across the surface of the paper, allow the figure shape to evolve. Keep the images to no more than about 3 cm (1¼ in) in size.

small. Try also 'letting go' completely and work from your imagination only. Start with a random mark or blob in paint and allow these initial brushmarks to suggest how the rest of the figure should progress. Further interesting results can be achieved painting groups of figures in this way, linking them together in a mass.

MOVING FIGURES

As you progress, moving figures should also be attempted. With these it will be necessary to draw very quickly since you will only have a maximum of about five or six seconds to complete a drawing before your chosen subject has gone. In contrast to a posed model, moving figures possess a purpose or

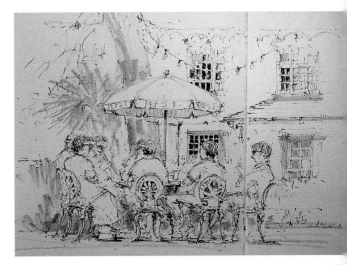

A sketchbook page of figures, 20 × 30 cm (8 × 12 in), in a hotel garden produced in pen and pencil. When attempting groups of figures it is preferable to concentrate on one figure at a time, gradually assembling your drawing. In this way you will minimize the effect of movement. I added the background in this drawing when the group had moved away.

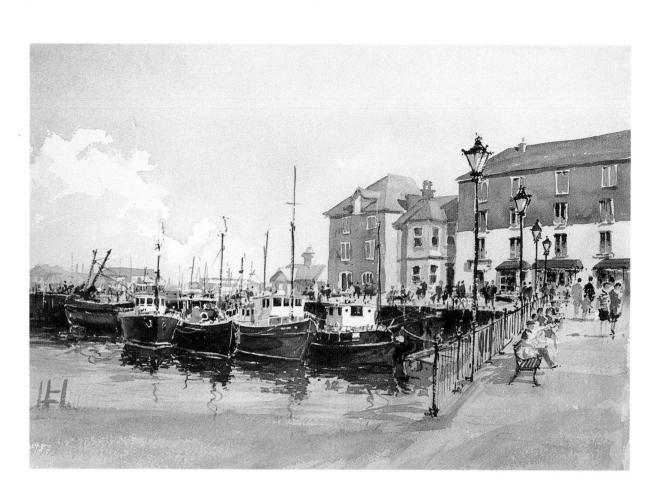

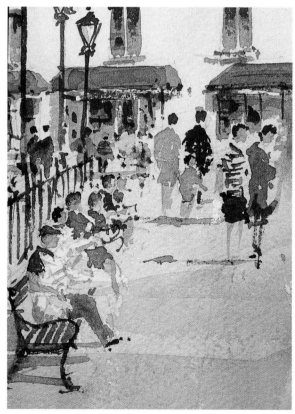

▲ PADSTOW, CORNWALL
watercolour, 36 × 53 cm (14 × 21 in)

Though the figures in this painting are incidental to the main theme, without them the image would have remained rather static.

◀ Detail from Padstow, Cornwall, *showing how the figures have been suggested with minimal brush marks.*

FIGURES IN PAINTINGS

Making small painting studies using your own sketches as reference material will offer opportunities to practise your figure work further. Since your sketches will have been produced from your own observational responses they should contain the essential information to convey the mood of the figure. Do not try to make your paintings exact copies of the original, but use your sketches as a starting point to which you can then

▶ STREET SCENE
watercolour, 30 × 20 cm (12 × 8 in)

Though the figures in this painting formed a more dominant role I avoided painting them in too much detail in order to give the impression of a busy environment.

either add in elements from other sketches or invent from your visual memory as you choose. In this way you will be more likely to produce a fresh, lively interpretation rather than the painting process becoming a mere copying exercise.

When introducing figures into paintings that are incidental to the main subject, it is essential that they still appear to belong, in terms of scale, location and character, rather than appearing to have been stuck in as an afterthought.

Added authenticity can also be achieved if they display the right gesture relative to their location. Before including them consider how they might help to add to the story or theme of the picture. In the background and middle distance they can be laid in as a broad mass, as in the brush 'doodles' on page 59. In the foreground they will then need to be depicted more accurately, though not necessarily with meticulous detail.

The more you are able to observe and draw from life the greater will be your potential for invention, but initially referring to your own stock of sketchbook drawings can be the starting point for finding suitable images when you need to incorporate them into your paintings.

Through our body language we continuously give out specific information about ourselves to the world around us and if your figures can capture this underlying characteristic, even when portrayed only by the briefest of brush marks, they will always appear more lifelike.

▶ *An oil sketch, 30 × 20 cm (12 × 8 in), depicting street figures. I combined different sketchbook drawings in order to assemble a new image. My aim was to try to portray a feeling of movement within the figure group.*

WOODLAND SCENES

*How do I tackle woodland effectively?
There are so many trees and undergrowth
masses to deal with.*

Answered by: **Jackie Simmonds**

Woodland scenes are enchanting and really difficult to sort out. You sit to sketch, full of enthusiasm, and you quickly realize that there are far more trees than you can possibly cope with, and the undergrowth is horribly complicated. There are leaves everywhere, too. This all sounds rather obvious, but somehow the way we imagine woodland scenes, and what we actually find when we come to paint them, seem to be two different things. Painting a woodland scene is not quite as

BLUEBELL WALK
pastel on paper, 36 × 56 cm (14 × 22 in)

In this image only the tree trunks and the people are depicted literally; the undergrowth and leaves are simply suggested with dots and dashes. However, it is perfectly clear what this picture is all about. The picture is divided into three main areas: a dark top area, a lighter centre section, and a dark bottom area. This is the way to think about composition, rather than thinking only about trees, people and bluebells.

straightforward as a landscape that splits up the rectangle into nice, understandable sections of foreground, middle ground, distance and sky.

Let us think about what we might find if we look through a viewing rectangle, or the viewfinder of a camera. The top half of the picture is likely to be a tangly mass of branches and foliage; the bottom half of the picture a tangly mass of tree trunks, branches and undergrowth foliage.

USE A VIEWFINDER

The first step has to be to sort all this out, and the best way to do this is to find a way of forcing the tangle into a cohesive design. Spend some time looking at the scene through a viewfinder. Try it both vertically and horizontally. Squeeze your eyes together and squint as you look through at the scene. Try to squint so much that it is impossible to discern individual leaves. If you do this properly the whole scene should dissolve into simple shapes and masses. Try holding the viewfinder close to your eye, and then further away. After a few minutes squinting like mad you may begin to see some possible compositions. At this point, try a few little thumbnail sketches.

CHARCOAL SKETCHES

Stop yourself from getting too involved with twigs and leaves by using a broad medium like charcoal for your thumbnail sketches. If you use a pencil, its point will encourage you to be fiddly, but charcoal is terrific for simplification. Give yourself a time limit of, say, five minutes for a thumbnail sketch. This will force you to simplify, too.

Used on its side, a piece of charcoal stroked across the paper will give you a really good starting point. Have a look at my example on the right. The top sketch is simply charcoal spread across the paper, using the side of a short piece. Even though I used cartridge paper, there is some texture showing through, which you can leave if you wish.

For the bottom sketch, however, I softened some of the texture by rubbing gently with a finger. Then I worked over the top, both with the edge of the charcoal for the dark trees, and with a putty eraser, picking out light shapes. I began to find and exaggerate shapes – the zigzag shape of the path, for instance, echoed in some of the tree branches. I also

liked the element of counterchange – some trees dark against light, others light against dark.

I suggested the ground plane lightly, with marks to show that the ground sloped down towards the path, again emphasizing the diagonal element, which nicely balances the vertical forms of the trees.

There was lots of undergrowth in the scene, and masses of leaves – and yet, although I have not created one obvious leaf, or fern, it is perfectly clear that this is a woodland scene.

Trying out thumbnail sketches in this way is invaluable. In them, you can try to discern not only the main shapes and masses within the scene, but also rhythms, movement and echoes. A curving pool of light on the ground, for instance, might be echoed in the sweeping arc of a large branch. A pathway moving into and through a wooded area towards, perhaps, a bright shape denoting a sunlit clearing, or a dark shape representing a mysterious and interesting copse, will encourage the eye of the

Stroke charcoal across the ground for texture (top sketch), then work into the surface with your finger, putty eraser and more charcoal (bottom sketch).

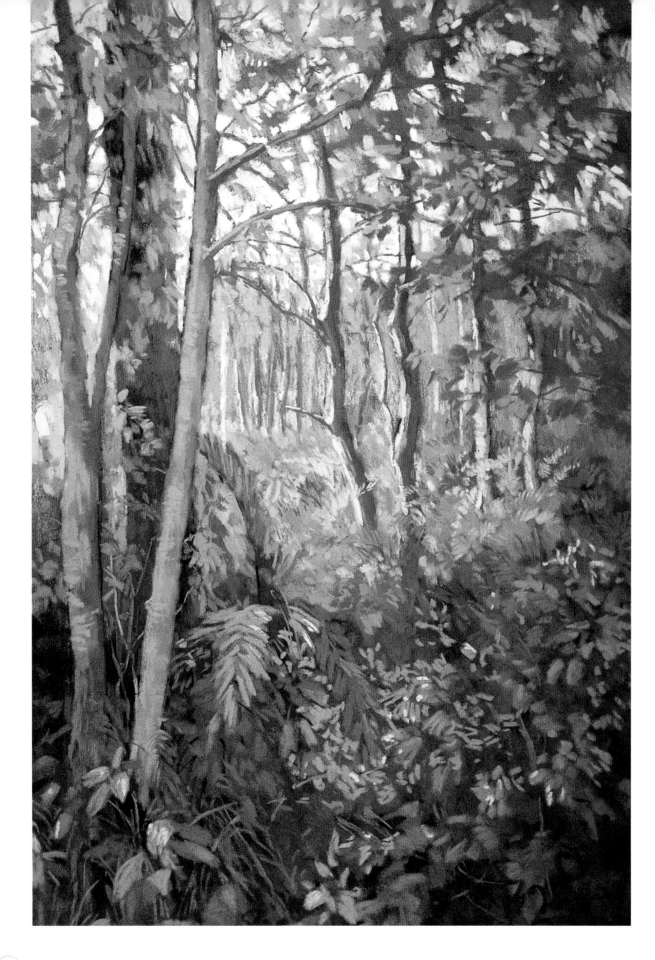

viewer to move into the picture, rather than come up against an impenetrable wall of foliage. Finding patterns, and abstract shapes, in your charcoal sketch will give your painting strength; having a well-designed, underlying geometric pattern will always reinforce a painting.

Here is a checklist that you might like to copy into your sketchbook:

• Sort out the scene into its simplest light, medium and dark tones.
• Group closely toned areas together to create a pattern of fairly large abstract shapes.
• Aim for no more than five main, large shapes in your picture.
• Try to find echoing shapes – if they are not obvious, consider some shapes to create echoes.
• Look for rhythms. Branches will create patterns not only in the way they grow, but also in the spaces that you can see between them, for instance. You may find similarities in the shapes and lines in the image that act like a repeating chord in a piece of music.
• Try to create a focal point in your picture – a main tree, or group of trees, or a pool of light, or an area of counterchange, light against dark, dark against light, for instance.
• Consider the underlying geometry of the scene. Does it consist largely of vertical elements? Diagonal elements? Curving forms? Make one of these ideas dominate.
• Always work from the general to the particular. Work broadly without detail in the early stages, and add details last.

TALL TREES, AUTUMN
pastel on paper, 51 × 30 cm (20 × 12 in)

I was fascinated by the height of these tall, slender trees and so I chose a vertical format. I used the element of counterchange – light trees against dark in the foreground and smaller, dark trees against light in the distance. Large marks in the foreground and small vertical marks in the distance give a good sense of recession. I have depicted lots of foliage, both leaves and ferns, but if you look closely, you will see that only the foliage in the foreground is described. I wanted the viewer to look through to the light, middle distance.

Areas of colour combine visually with a few lines to convey the impression of massed foliage.

TACKLING FOLIAGE

It is perfectly possible to create the impression of foliage masses without even hinting at a leaf. In the little coloured example above, my marks are simply blocks of colour, and yet the addition of a few simple lines makes us understand that we are looking at trees. Of course, there is no need to feel that you must simplify to this extent; it is simply that the viewer is quite able to work out what the painting is about, even if you leave areas suggested.

I enjoy a painting that allows my imagination to work when I look at it. If I see a picture where every leaf and blade of grass is painted, I can admire the patience of the painter, but I often wonder why he felt he had to paint in this way when a camera would have done just as good a job. Abstract shapes depicting clumps of foliage can be perfectly convincing – and often very exciting. If, however, you want to include more information, simply use some sharp accents to describe the construction of the main trees in the scene, with some hints as to the nature of the foliage, since trees differ greatly in their foliage types. But do not overdo it.

Painting effective woodland scenes does not depend on your attention to detail. Many

non-painters who look at paintings will, more often than not, be fascinated and impressed by the detail. But, if you concentrate solely on depicting hundreds of leaves and branches in a woodland scene you will fail to capture the magic and intimacy of the scene.

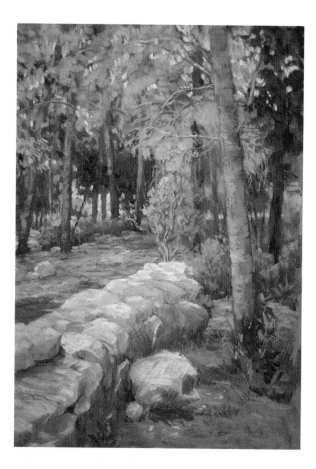

▶ THE BRITISH PARK, ISRAEL
pastel on paper, 53 × 30 cm (21 × 12 in)

Foreground rocks form a light shape, leading the eye diagonally in and towards the smaller background area of trees. The trees are tall, vertical shapes, but underlying diagonal elements give interest and variety.

▼ REMAINS OF AUTUMN
pastel on paper, 56 × 66 cm (22 × 26 in)

Woodland scenes can be extremely intimate. Look hard in the background. The distant trees are a simple colour area. The foreground, close to the viewer, is more literally described and yet the foliage is still understated. I enjoyed the rhythm of the curving elements to create a sense of flow from left to right.

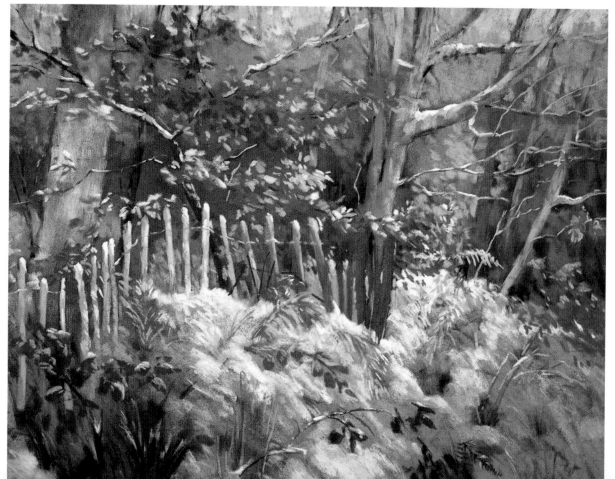

14

SHAPES & RHYTHMS

How can I bring life to my painting and drawing of animals?

Answered by: **Peter Partington**

Like many teachers before me, when I am taking a wildlife sketching class I get the students to 'free up'. I encourage them to loosen up, to work on large sheets of paper and to explore the gestural, swirling movements offered by wrist, elbow and shoulder. Charcoal and soft pencil are ideal for this. Gradually we move towards more specific shapes; those to be found by the perceptive eye in the animal world itself.

We practise ellipses, teardrop shapes, uncoiling springs and spirals, whiplashes, S-bends and 'lightning' strokes. The point is achieved when some of these shapes begin magically to suggest the rhythms of life and vitality in the animals and birds we are drawing.

DYNAMIC SHAPES AND LINES

I took one such class in the large-windowed, warm observatory at Welney Wildfowl and Wetlands Trust Reserve, Cambridgeshire. On offer here were ideal conditions for drawing ducks, swans and waders. Feeding time presents the seething spectacle of a mass of ducks competing for seed. The Pochard drakes, in particular, turn this way and that, bobbing and diving energetically; the turmoil further enhanced by the ripple and splash of the water. Was this an artist's nightmare to depict? No, not necessarily, for all the ducks had one shape in common – the dynamic teardrops of their bodies, as well as the S-bends of their necks and their circular heads.

At the point where the students are freeing up with these shapes, covering the paper with a mass of random and overlapping attempts, they find, not unsurprisingly, that they already have something of the scene before them, as in the drawing exercises of ducks here. They have already captured, through

Gaining control of gesture and spontaneous shape-making is an essential prerequisite of drawing. Here I have used pencil and wash on cartridge paper. A swirling mass resolves itself into teardrop shapes. Observation and understanding come from closer study of the Pochard drakes and this knowledge can then be applied to the dynamic substructure. The more you work in with colour, light and detail, the more danger there is of stasis. The two processes of control and freedom can be practised constantly alongside each other.

◄ *Dynamic spirals and compressed 'Z's are the elements in this study of cats made in pencil and wash on cartridge paper. The upright sitting posture shows the simplest format of the extended spiral that sweeps up the cat's body. The disposition of the bones in the limbs is upright. The neck curves back into the body. It helps to treat the head as a separate entity sitting on the neck. The crouching posture shows a similar spiral and the limbs lie more horizontally.*

the moving line, something of this chaos of living nature. It would be possible for such preliminary sketches to be developed in more detail, with light, colour and tonal values. Such a course would entail further observation and study to capture the pattern and character of the ducks, which is fine if the work still retains the exuberance of the movement and rhythm of the original loosely drawn sketches.

These dynamic shapes and lines stem from the animals' own anatomy. It is useful to know something about how they move. The quadrupeds

share a common arrangement of limb structures. When an animal such as a cat is at rest the bones of the limbs compress into a 'Z' configuration and when they are stretched, extend into what I term the 'lightning' stroke. These are useful 'linears' to hold in mind as you sketch your domestic moggy in all its feline grace. It is possible to visualize the beast as a coiled spring powered by the compressed 'Z' of its rear limbs. Here again you can use your cat as an excuse for rhythmic lines. The sinuosity and dynamic curves of the animal can be mirrored in the movements of your wrist and elbow.

▶ *I made these studies of deer and curlew in pencil on cartridge paper. From side view the trunk and legs of the deer fit into a rough square. The overhang at the rear is a clue to the tripartite disposition of the bones in the rear leg. When stretched, these bones can form a flat zigzag. This dynamic 'linear' will help you grasp the leaping shape. From behind, a quick circle and triangle, point down, is a useful way of suggesting mobility. The knee of the curlew is concealed behind its flank feathers, but the similarity of the bone position to the rear leg of the deer is apparent. From behind, as the bird steps forward, the legs appear to meet at the feet.*

CATS PLAYING

watercolour on cartridge paper, 25 × 23 cm (10 × 9 in)

I used loose brushwork here with a rigger brush, with strong paint on a damp surface to soften the lines. This softness helps the sense of fluidity that is appropriate for felines. Practise with the brush before you begin, trying out all the curves, 'S' bends and whiplashes you can create.

In *Cats Playing* I have tried to express their interlocking spirals and shapes. My excitement and delight in their lively game of mock triumph and capture between mother and daughter results in a response where physical gesture comes first; almost any lines thrown down will do to express their activity. Improving the accuracy of line and knowledge of their anatomy can come later, as will considerations of media such as wet-in-wet brush for fluidity or charcoal for tonal richness. These will emerge naturally from watching the life of the cats before you start to draw. Always go back to your models. That is the golden rule.

DRAW CONSTANTLY

Some of the simplest mammalian shapes are offered by seals. *Basking Seals, Skokholm Island* shows how their hydrodynamic forms resemble extended water drops with added sinuosity.

BASKING SEALS, SKOKHOLM ISLAND

watercolour, 11½ × 14½ in (29 × 37 cm)

I drew these seals on the spot on 300 gsm (140 lb) Rough paper. They composed themselves naturally. The animals are fairly somnolent, but the dynamic S-bend of their water-drop shapes suggests a potential for movement. Their forms are simple, but subtle. I used the spots on their pelt to suggest colour.

FLEEING ROE DEER

pencil, watercolour, gouache and chalk, 38 × 57 cm (15 × 22½ in)

The stimulus for this study, made on 300 gsm (140 lb) Rough paper, came from the animal in the foreground, which my eye caught in mid-leap after a lucky near encounter. The next deer took a lot of drawing to work out carefully beforehand, using the 'lightning' stroke effect, in this case foreshortened. This picture might eventually be rendered in pure watercolour, but I use any medium to work towards the realization of the idea.

The deer is as sure-footed and as graceful as the cat. It, too, can compress its limbs while resting or demonstrate the 'lightning' stroke when stretched to the full as it leaps. In *Fleeing Roe Deer* I have depicted them as we often see them, bounding away from us as fast as they can. The nearest deer has its limbs compressed in full jump, while the next has its forelimbs stretched to meet the ground. The further two are more approximate, but the impression of movement is still maintained by suggesting the feet are on points like a ballerina. The whole study was thrown down very quickly: the dashed-down marks of trees, twigs, grass and ferns all keep the eye busy and add to the impression of movement. Sometimes it is impossible to improve on a sketch as it is expressed with all the enthusiasm of the original experience.

Swans are recognized as the epitome of grace and dignity, at least when they are flying or floating serenely on the proverbial lake. On land their large feet suggest they are struggling to get along in heavy wellies, as my pencil studies suggest. I like this contradiction and the pose it produces. The underlying teardrop shape will be pushed forward over the legs. The S-bend of the neck is balanced on the crop and is surmounted by the small head. The latter can turn almost 180 degrees while the neck remains gently curved.

Other rhythms are to be found within the body shape, like the flattened 'S' of the combined wings and flank feathers. Observation will enable you to add to this substructure and elaborate with authentic detail.

The secret of capturing movement is to draw constantly without any anxiety as to the end product, getting involved to the point where you forget yourself. You can work from photographs, but they can be static and should be interpreted with rhythm and feeling. Video footage is better: there is a plethora of animal film to choose from. Again draw from them looking for weight, balance, musculature. Dash down your sketches as fast as you can, but stop to look first.

We apply the term 'movement' liberally to most drawing and painting. Once painted, of course, the image remains static; it is our eyes that move and dance over the picture's surface. It is the artist's ability to create a dance for the eyes that gives your pictures of animals life and movement.

▶ *You can begin all bird shapes with a teardrop. The gentle S-curve of the neck moves up to the head, which can be started with an oval at the top. The wings and flanks form a flattened S. On this you can elaborate with more detail if you wish. The body shape shifts forward in weight when the swan is standing. The legs of birds operate rather as the back legs of a mammal. From behind or in front the body can be quickly drawn as a circle. To draw it feeding, find the head position first and loop the long neck to fit. Practising these movements from memory can familiarize you to the point where you can draw by instinct.*

UNITY IN STILL LIFES

I like painting still lifes but always seem to have problems with the background.

Answered by: **Anuk Naumann**

Apart from the self-portrait, the still-life painting is the most personal work an artist produces in that it says so much about the painter. The choice of objects within the painting can reveal a great deal about the artist's possessions, hinting at favourite pieces of china or heirloom lace tablecloths, giving us a glimpse into a corner of the studio or kitchen,

▼ **BOWL OF CHERRIES**
mixed media, 23 × 23 cm (9 × 9 in)

I decided on a viewpoint that looked down on the subject. The circle of the bowl is carefully placed off-centre of the square format to make a pleasing composition. The linear pattern of the carpet makes a successful foil to the round cherries.

► CHERRIES IN PORCELAIN BOWL
watercolour,
18 × 18 cm (7 × 7 in)

A simple dark background heightens the visual impact of both bowl and cherries.

showing us the personal influences that have come together to create the painting.

As the work is personal, and each artist's solution to the problems solved in their own way, there is no single answer to the problem of boring or unsatisfactory backgrounds, but some pointers that I give to my students may set you thinking about your own approach.

In each illustrated example I have used a favourite subject, that of a bowl of cherries, to show that there are many ways to explore a theme.

COMPOSITION

Still-life painting gives the artist ultimate control over the subject chosen, the composition, the colour and even the lighting. Beginning with the basic choice of format, I decide before even selecting my still-life pieces whether my final painting will be landscape shape, portrait or, my favourite option, square. Keeping this square always

in mind, I begin to place my objects carefully, taking note of the space they inhabit and the negative spaces in between. Using mountboard cut as a viewfinder, I assess how well the objects fill the area to be painted, and adjust if necessary.

At the same time as placing the pieces for painting I have in mind what my viewpoint will be. In the simple study *Bowl of Cherries* I was obviously looking down at my subject, which I had placed on a Persian rug, chosen for its wonderful richness of colour and pattern. Using this device, I was able to resolve immediately any background problem; the rug naturally created a background as part of the simple composition.

A point here, which cannot be stressed too often, is that I always think of how I shall treat the background at the same time as I am composing the picture. The two are inseparable in my view.

In *Cherries in Porcelain Bowl*, also on a Persian rug, I viewed the bowl in its upright form to show

CHERRIES
watercolour, 18 × 18 cm
(7 × 7 in)

In this composition the bowl of cherries is viewed straight on, but placed off-centre in the square format. The dark backgound provides a solidity for the diagonal folds of the cloth, while the overall atmosphere of the painting is of freshness.

the intricate pattern of the porcelain. Here, the rug plays a less dominant role, with just a faint impression of its colour and pattern merging into what essentially is a plain dark background. Keeping the background simple helps to highlight the drama of the bowl with its glistening contents. But rather than just applying a wash of colour as an afterthought, the background is made up of a series of washes, using colours from the cherries themselves to create harmony. I also avoided a rigid line between the horizontal and vertical plane, blending the two. The stalks of the cherries punctuate the dark surround, giving added interest.

With *Cherries* the background is again a dark variegated wash, used this time to offset the sparkling white of the teatowel in whose folds nestle the patterned bowl and its fruit. Here a different emphasis of pattern and depth has been achieved, with the background giving solidity to an otherwise light composition.

COLOUR

The use of colour can be applied in solving the problem of how to deal with backgrounds. In *Cherries and Orange Jug* detail has been kept to a minimum and the colours used determine the sense of space within the painting. By using the complementary colours orange and blue, and moving them through the painting, the background is connected to the foreground. Shapes are kept simple and abstracted, with a mere suggestion of a table edge outlined. Splashes of hot pink connect the red of the cherries to the rest of the picture and it is hard to see where the background begins or ends – in fact it is an integral part of the whole.

Colour is also used to determine the mood of the painting. An overall wash of Cadmium Yellow and orange was applied to the canvas in *Mediterranean Still Life* on page 76 to give the feeling of heat and sun. In one go, two problems were removed: the blank white canvas disappeared and an overall

colour theme was given to the painting that helped
to determine the feeling of the background. The
painting was then built up in stages, with the
cherries painted first while they were still fresh and
succulent. As with all the other paintings, the
background was painted together with the rest of
the picture, not added in at the last minute.

PATTERN AND TEXTURE

The use of pattern and texture in a painting can
help to unify the different elements of the picture.
A still-life artist needs to have a strong magpie

CHERRIES AND ORANGE JUG
mixed media, 38 × 38 cm (15 × 15 in)

*Painting the elements as abstract shapes allows the
opportunity to give more emphasis to choice of colour.*

instinct, collecting all sorts of interesting pieces of
china or patterned cloths that will some day be
useful in creating the right composition. When the
desired flowers and fruits are in season, various
other props can be brought out. In *Cherries and
Lilies* just such a selection of old favourites was

MEDITERRANEAN STILL LIFE
mixed media on canvas, 41 × 41 cm (16 × 16 in)

A sunny scene conveyed by the use of various oranges and yellows is enhanced by complementary blues.

employed. The Persian rug forms part of the background, together with some abstract patterns, which I added to fill the composed space.

In this painting, as with *Mediterranean Still Life,* the element of imagination has also been used. Where there is no background set up I create one from my imagination to fit in with my overall theme. Such 'bending' of the facts can include distortion of perspective, adding an imaginary window or landscape behind the still life, or manipulating areas of colour and shape to complement the foreground objects.

The order in which a picture is painted can determine the final effect. In careful studies, such as *Cherries in Porcelain Bowl, Bowl of Cherries* and *Cherries,* I started with a drawing of the bowl of cherries. For this I usually use watercolour crayons rather than pencil, so that the marks disappear when watercolour is applied. I then work with brushes loaded with pigment, moving around the

CHERRIES AND LILIES
mixed media, 38 × 38 cm (15 × 15 in)

This composition combines different viewpoints,
which are linked by the background patterned carpet.

painting, taking care not to have one whole section
completely finished before moving on to the next.
In this way I avoid the problem of having
meticulously painted all the interesting elements in
the foreground of the painting only to discover a
blank area in the background. With more abstract,
looser compositions, I sometimes start at once with
paint and omit the initial drawing. In this way areas
of colour can be applied to all areas of the work,
tying the composition together.

Some of the most exciting still-life studies
happen by accident; a chance group of objects on a
window sill, or a shaft of light throwing interesting

shadows on a wall behind random pieces in the
studio. In these cases, the background is already
there as part of the composition. The challenge is to
create that same feeling of unity in a contrived still
life. With attention to composition and detail and a
feeling for the painting as a whole, all you need is
your imagination.

CHILDREN AT PLAY

I would like to paint children playing on beaches, but they are always moving about. How should I tackle this subject?

Answered by: **Jackie Simmonds**

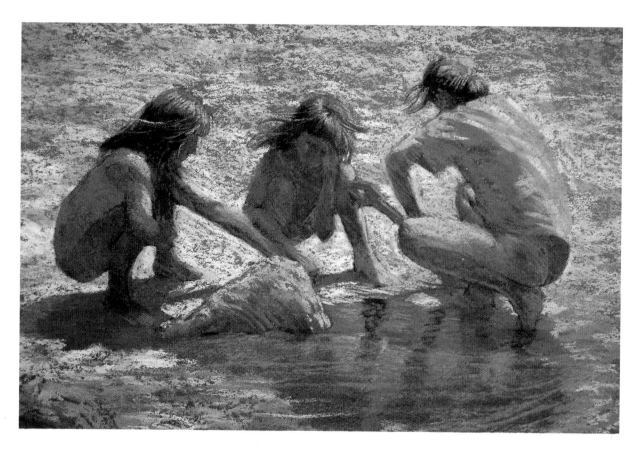

ROCKPOOL TRIO
pastel on paper, 41 × 53 cm (16 × 21 in)

Although together these girls seem to form an oval shape floating in the centre of the rectangle, they are actually anchored to the bottom and sides of the rectangle by the colours in the puddle, and by their shadows. This was not immediately apparent in the scene – I had to emphasize these elements to make a stronger composition.

Everyone enjoys watching children at play, their bodies falling into uncontrived, fluid poses. With their natural curiosity and uninhibited close communication, they offer lovely subjects for sketching and painting, although since they rarely remain still, it is no easy task to capture on paper what you observe in action!

THE VALUE OF DRAWING PRACTICE

I found it heartening to read the words of David Curtis, in his book *The Landscape in Watercolour*: 'even quite competent painters have trouble with figures'. But he goes on to say, usefully, that if you

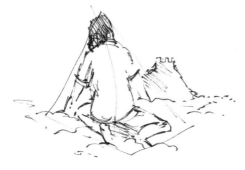

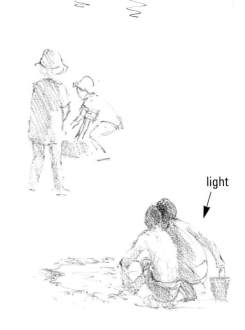

*These are very rough, quick sketches, mostly
unfinished as the children moved away, and in
some cases quite tentative, as in the little sketch
bottom right. The girl in the centre is not sitting in a
tent: I indicated the general shape of the pose before putting her
in, and began with the curve of the spine. Notice how the few
lines used to indicate sea and horizon on the sketch bottom left,
help to locate the children in space and scale.*

light

have not reached a stage of great fluency in drawing
yet, you should consider photographing moving
figures, and then 'bring in a figure from a
photograph'. However, he recommends that you
also use a small sketchpad so that you sketch people
and children whenever you can. Although a camera
is extremely useful, it really helps to spend time
sketching just for the sake of it, even if the results
are unfinished. The value of looking hard and
trying to get a few well-observed lines down in your
sketchbook cannot be overestimated. If you back up
that sketching session with a photograph or two,
when you come to work on the painting your

memory of the scene will be supplemented by the
record of the photograph.

USEFUL TIPS
There are a number of points to bear in mind when
drawing children:

● Remember that their heads are larger in
proportion to their bodies than those of adults. If
you make the heads too small, they cease to look
like children, but become more like small adults.
● Try to capture the overall pose that attracted you,
as quickly as possible, by squinting so that you see

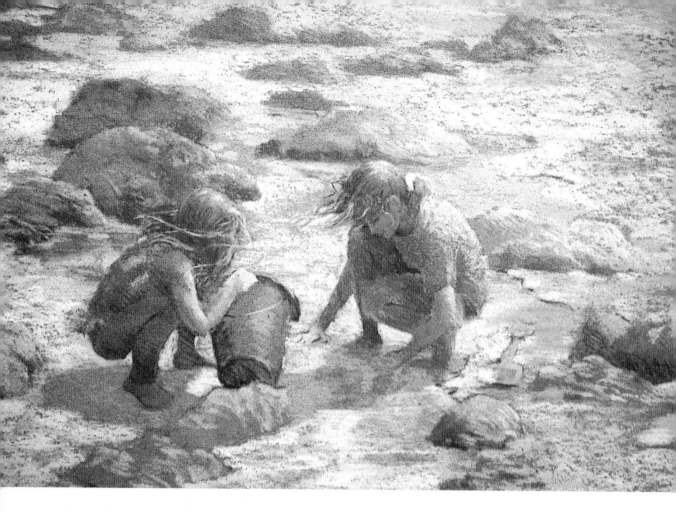

CURIOSITY
pastel on paper, 46 × 61 cm (18 × 24 in)

I borrowed the surroundings for these two girls from another scene, as I originally saw them on a rather featureless area of sand, playing in a small puddle. Painting them that way would have isolated them in the middle of the picture. As it is, the shapes of the rocks and water echo and link with the crouching figures, and with the edges of the rectangle.

the whole body as a simple, large shape. Draw in the curve of the spine first, and possibly the angle of the shoulders, and then block in the shape of the body. Where children are playing close together, with their bodies overlapping, squint even harder, to see the shape that they make together.

● Do not worry too much about general proportions in your rough sketches: you can sort those out more carefully when you look at your photographs. Also, do not worry about hands, feet, and features in your quick sketches – you can solve the problem of facial features by looking for

children with their heads down, or who are facing away from you.

● If it is sunny, indicate the direction of the light falling on the figures – this will help with the subsequent placement of shadows. If you use outlines round the body, allow the line to be lighter, or broken, on sunlit edges. If you have time, block in the shadow as part of the figure.

● If time allows, try to indicate some of the surroundings in your sketches. This will help, in particular, with the relative sizes of the children to their surroundings. Draw the breakwater or the rocks, for instance – and then quickly indicate where the children's heads and feet are in relation to the static objects. Once these are established you might feel confident enough to add the children!

PAINTING CHILDREN AT PLAY

If you paint on the spot, you will be able to observe the colours in the subject properly. Working from a photograph is very different. A photo sometimes flattens colours and tones: a camera can never be as observant as the naked eye – and it is certainly not

as creative as the human brain! It is worth making notes about any interesting nuances of colour. For instance, light bouncing up from a puddle might subtly warm and illuminate skin tones that, in the shade, are predominantly cool. Brightly coloured objects such as plastic buckets might throw colours into areas of skin, or on to the surroundings.

If you like to work on the spot, but are nervous about including the figures, you could begin your picture in situ, working on the main elements in the scene, with small dots to indicate where heads and feet relate to the landscape. You might also be able to indicate the shapes of the figures, if they sit still long enough! Then you can finish the figures at home, after studying detail and proportions from your photographs if you need to.

On the other hand, at home, working from your sketches and photos, you have more time to think carefully about the composition of your painting. I always make a few thumbnail sketches before embarking on a final painting. In these thumbnail sketches, consider the underlying 'geometry' of the picture. Bring in elements from different photos to improve a composition if necessary. Simplify, remove, or change things. You could even trace over certain figures, and try reversing them, as I did in *Boys with Buckets.* See where you can use the principle of 'lost-and-found' – emphasizing some

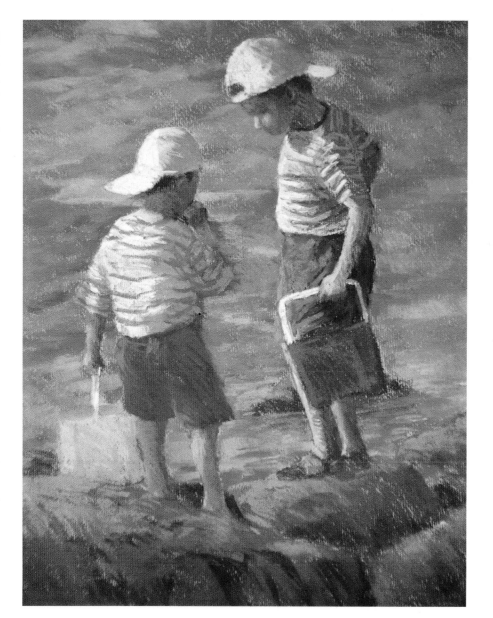

BOYS WITH BUCKETS
pastel on paper, 33 × 25 cm
(13 × 10 in)

In the scene, and in my photograph, these boys were facing away from each other. Determined to use them somehow, I turned one of them around in a thumbnail sketch and there it was – the ideal composition to express the mood I wanted. I deliberately used bright simple colours for their clothes, and buckets, which, I felt, emphasized the innocence and joy of youth. Also, their clothing style sets them perfectly in a timescale.

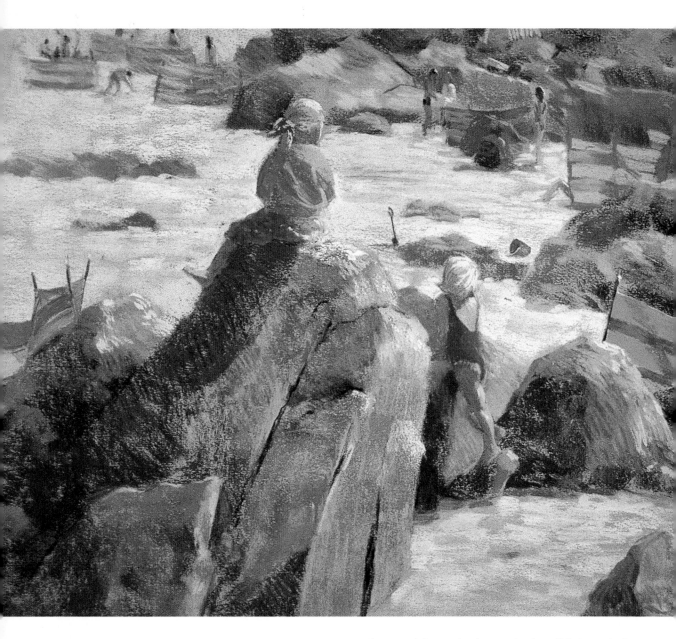

THE RED SWIMSUIT

pastel on paper, 41 × 53 cm (6 × 21 in)

Here, the bright colours of the girls' clothing, and the gaily coloured stripes of the windbreaks, are a lovely foil for the blue-grey rocks and simple areas of sand. In my photograph there was an ugly breakwater behind the rocks: I left it out, and introduced more rocks, and suggestions of windbreaks and people, to take the eye back into the picture. I ensured that the head of the child sitting on the large rock overlapped the background rocks: this links foreground with background nicely. I could not have produced this picture without a thumbnail sketch, and taking a number of photographs provided ample reference.

edges, and 'losing' others, which will help to link the figures with their surroundings.

I work in a very traditional way, trying to recreate three-dimensional form, but you might prefer to simplify your figures into simple areas of bold, flat colour. How you paint your picture, the technique you use, is a very personal matter, and there are many different approaches, from the very realistic to the highly imaginative.

PHOTOGRAPHY AS A TOOL

Many artists feel that working from photographs is cheating, but remember that many fine artists have done just this in the past – artists such as Degas,

▶ *These photographs were used for the painting* The Red Swimsuit. *I did not like any of them individually, but managed to put together elements from each in a thumbnail sketch, to create a far nicer scene, with an interesting pictorial composition. Notice, too, how I have adjusted the colours in the scene, warming the sand, and putting far more colour into the rocks. Faithfully copying the colourless darks and lights would have been far less effective.*

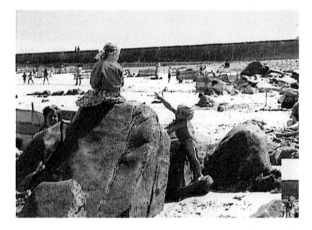

Sickert, Manet, Paul Nash and David Hockney, to mention a few. The golden rule – if ever there is such a thing in painting – is not to copy mindlessly. You must use, together with your photos, two further important ingredients: your intelligence and your creativity. I have seen many pictures in art society critiques that were obviously painted from photographs and contained strange shapes or passages of colour. When questioned about such elements, the artist will say defensively 'Well, it was there'. But if you cannot identify something, do not use it.

Trying to capture children at play has given me enormous pleasure. I am sure you will enjoy it, too.

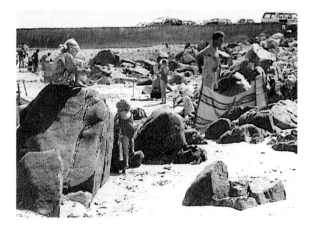

ILLUSION OF LIGHT

How do I achieve a sense of light in my watercolours?

Answered by: **Gerald Green**

One of the most challenging aims for the watercolour painter is to paint light. To do this you must learn the means to convey the effects of light in your paintings in order to kid the brain into perceiving the level of illumination required. This is achieved principally by controlling the distribution of tonal values (lights and darks) rather than from use of colour since it is light and shade that enable you to see the shapes of different things and to determine space, distance and atmosphere. You can prove this by changing television pictures from colour into black and white; you will see that this makes no difference to your ability to see things as they actually are.

In order fully to appreciate the theory I recommend that you first do some small monochrome illumination sketches similar to the paintings of boats here. These three images show

Normal light (above left) *Here there is a general range of values from white to black with various steps of grey in between. There are also maximum value contrasts, white against black. In colour this would be depicted in strong hues.*

Dim light (left) *The overall image here tends towards a dark grey field or scale. As illumination becomes dim all deep values blend together – colours would become blackish and muted.*

Misty light (right) *Under these circumstances, compared with dim illumination, the overall image will generally appear light grey with the blacks and dark greys becoming lighter. Thus the overall tonal range is reduced from white to mid grey rather than extending through to black.*

different qualities of illumination. Each was produced in Lamp Black watercolour. When making small studies like these, 15 × 20 cm (6 × 8 in), the aim should be to try to make the lighting effect transcend the medium, but the full effect will only become apparent when all the paper has been covered.

Repeat the exercises incorporating your own subjects, and for variety you could use any colour that will make a strong dark. If you are able to produce the effects of light in monochrome first, you will be more likely to be able to do so when working in colour.

COLOUR AND LIGHT

Colour influences the way light is perceived in paintings, but its effect is essentially supportive, acting as an addition to the main tonal structure of the image. As we are attracted to paintings by their colour harmonies, it is understandable that we are sometimes mistakenly persuaded to believe that colour is the principal influence of light in paintings. But, as in music, colour harmonies without a definite key or tonal arrangement to set them against remain discordant and meaningless when we view them.

One way to reduce the likelihood of this happening is to be selective – choose colours that will add to the mood or atmosphere that you wish to create rather than randomly dipping in to all the colours in your palette.

As a guide, analogous colours – those adjacent on the colour wheel – will generally give a feeling of harmony and tranquillity, particularly if used with smooth changes of tonal values. Conversely, complementary colours – opposites on the colour wheel – can suggest energy or diversity, particularly if used with strong tonal contrasts. Primary colours will be brighter than the more muted earth colours, which are closer to the colours of nature.

Whichever colour combinations you use it is essential to consider them within the context of the whole painting, allied to the equally important characteristics of shape, tonal values, line and textures. One rule to bear in mind when working with watercolour is to try to keep your colours fresh and clean. I suggest that you never mix more than two colours together in your palette prior to applying them to the paper, and overpaint as little as possible to prevent any likelihood of your colours becoming muddy.

CREATING LIGHTS WITH THE PAPER

The directness of watercolour is ideally suited to the production of dramatic lighting effects. The two small paintings of figures on page 86 demonstrate how, through careful use of the paper, it is possible to influence the impression of light. The first was painted in the conventional manner by laying in the local colours of the figures first, to which further darks were added to show shaded areas. In the second image highlights on the figures were lifted in value and allowed to remain as white paper. Paint was then laid in, cutting round these highlights to describe the remainder of the forms, with additional darks included as before to add shading. The inclusion of a darker background described the outer boundaries of the highlights and also made them appear lighter still. Both images make use of the same colours, but the illusion of light has been intensified in the second solely by the alteration of the tonal values.

To portray the effects of light successfully it is necessary to adjust all the elements within the entire painting to support the illusion. You may find this easier to achieve if you adopt a slight shift in your thinking – rather than making your paintings of

These two small
sketches of figures
illustrate the method
of intensifying the
effects of lighting.
The key is in the
treatment of the
tonal parameters, the
lightest lights and
darkest darks.
In the top image
I painted the figures
in the conventional
manner and though
there is a feeling of
lighting it is subdued
and uninteresting.
The lower image, by
comparison, appears to
be more striking. My
approach was to
exaggerate the tonal
relationships by lifting
the highlights to white
paper. Only when the
paper was completely
covered did the
lighting effect become
fully apparent.

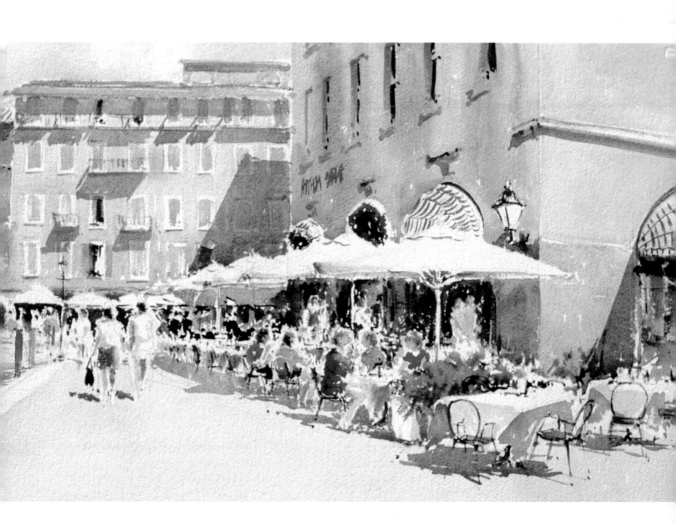

objects, be they flowers, figures, trees etc., try instead to focus on the relationships between the various objects or elements that go to make up your chosen subject. In this way as you proceed each part of your painting can be judged by its relationship to the whole.

Strong lighting will also generate well-defined expressive shadows and their treatment can help to intensify this illusion. The shape and direction of shadows can also be used to define form and space within a painting. They will generally tend to be cool in colour but this will be influenced by the local colour of any surfaces they fall across. Shadows are in effect negative light and should not be heavily painted as if they are solid objects.

ALTERNATIVE LIGHTING CONDITIONS

Observing subjects looking towards or against the light can offer still more opportunities to increase the vitality of a painting. Here, tonal contrasts become exaggerated. Objects seen against the light

PAVEMENT CAFÉ
watercolour, 36 × 53 cm (14 × 21 in)

I lifted the lightest lights to white paper, which I contrasted with plenty of darks in the main focal areas. I used mainly earth colours, but then added small areas of richer colour to add interest and further highlight the figures and tables in the foreground.

are in shadow and therefore tend to appear much darker against the brightness; intermediate or middle range tonal values tend to become lost.

As an alternative to the usual summer landscapes, try painting a misty or foggy scene. Familiarize yourself with the atmospheric conditions first by making some preliminary tonal drawings so that you can see how much the elements in the landscape are modified. Making tonal drawings will force you to see these effects more clearly. Notice particularly how distance reduces colours to a series of different greys.

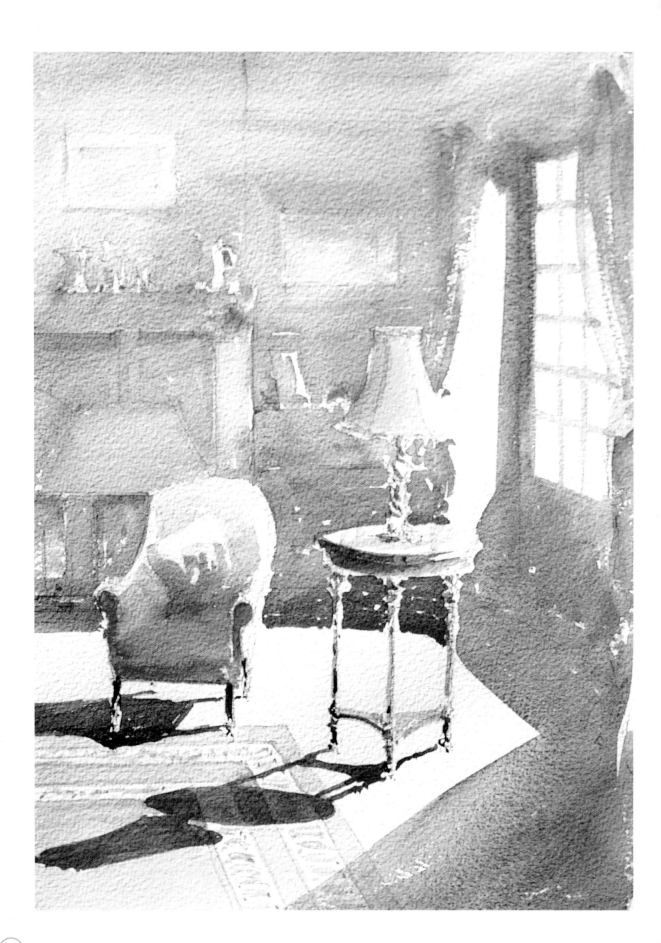

Allied to this, and relatively easy to produce in watercolour, is the effect of chromatic mist. Some intriguing results can be obtained. Begin by laying a colour wash over the whole paper first in blue or pale grey, or by using a more vivid colour such as pale violet or magenta if you require a slightly warmer look. All subsequent colours will then be modified by this underlying colour. Providing that you do not overpaint too much this will give an unusual general colour cast to the whole image.

The ideas suggested here are offered as pointers to help you negotiate your own way through the many challenges and often frustrations of working with watercolour, but any advice, however relevant, should never be allowed to take the place of personal expression.

◀ INTERIOR
watercolour, 36 × 25 cm (14 × 10 in)

Looking into the light. Before working in colour I first established the overall tonal pattern by trial and error, producing monochrome sketches to which I matched the colour passages in the final painting. Notice again how descriptive shadow forms are essential in portraying the illusion of light.

▼ MIXED FLOWERS
watercolour, 25 × 36 cm (10 × 14 in)

Lighting can also add extra vitality to still-life subjects. I generated the illusion of strong light in this painting by maximizing the tonal contrast between the light table top and dark shadow forms. I also included a dark background to help set off the lights on the flowers and jars.

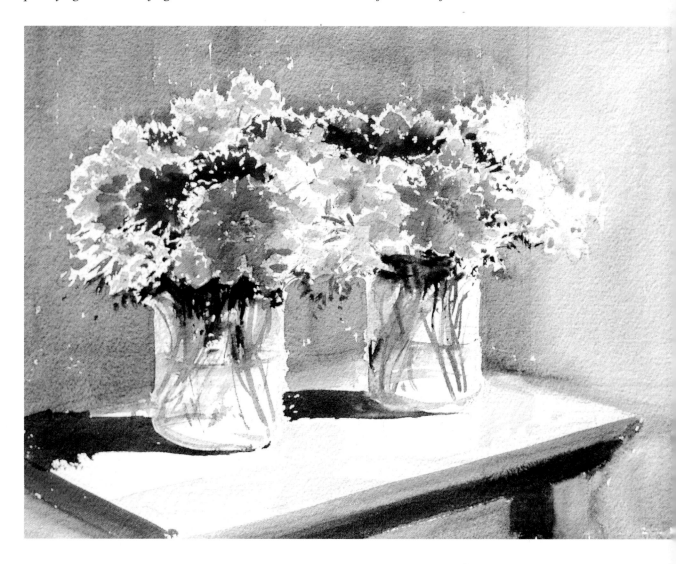

LIFE IN LANDSCAPES

How can I successfully convey a sense of life and activity in my landscape paintings?

Answered by: **Winston Oh**

I rarely paint a landscape without a figure in it because, as well as being a focus and giving the viewer a sense of the scale, most important of all, a figure brings life into the picture.

Life can also be expressed by movement, so I prefer my figures to be performing some activity.

SAN ROCCO, VENICE
watercolour, 36 × 51 cm (14 × 20 in)

A group of tourists give an idea of the enormous scale of the church, and provide spots of colour and movement: the walking figures are talking or looking at each other.

TOWNSCAPES

Simply positioning a grey, static figure in front of a building serves a purpose, but is a wasted opportunity. I normally prefer a figure to be walking, often carrying something: a walking stick, shopping bag, briefcase or an umbrella.

If there are two figures close to each other, try to relate one with the other. Indicate by their posture, or position of the head, that they are engaged in conversation. *San Rocco, Venice* shows a group of tourists walking in the rain. Note that the man without an umbrella is looking towards the solitary woman with a yellow headscarf, thus connecting her with the rest of the group.

If you want a figure to be stationary, he or she could be reading the papers, looking up at a sign or through a shop window, leaning against the wall, or even speaking into a mobile phone. All these activities are natural and commonplace and the viewer will easily identify with them.

Figures do not need to be painted in great detail. Whatever activity they are engaged in need only be hinted at, but prior thought and outline drawing

are advisable. In *Holland Village, Singapore* on page 93 the foreground figures and cars are rendered in softer tones, with a minimum of detail so as not to detract from the main subject – the row of colourful shops. The man using a mobile phone is put between the cars to reduce their sharp edges.

If you decide to use the figure as a centre of focus, by all means add more detail and use stronger colours for the clothes. I tend to use a red or yellow shirt or skirt in this instance. For further emphasis, a white hat against a dark background can be very effective. In *French Village House, Montresor* the straw boater is unmistakably the visual focal point.

A figure also gives you the opportunity to use its shadow for additional effect. For example, the

FRENCH VILLAGE HOUSE, MONTRESOR
watercolour, 36 × 51 cm (14 × 20 in)

The straw boater cast against the dark foliage stands out clearly as the visual focus. The narrow streets on either side invite the viewer to follow the figure.

posture of the graceful lady in *A Balinese Gateway, Indonesia,* painted in the artists' colony of Ubud in Bali, creates a shadow that completes a pleasing composition without any fuss or detail. The white banners on tall bamboo poles bending in the breeze add to the sensation of life and activity.

A BALINESE GATEWAY, INDONESIA
watercolour, 36 × 25 cm (14 × 10 in)

A lady looking through the archway of an elaborately carved stone gate casts a curved shadow. The white banners on long bamboo poles bend gently in the breeze and complement her shadow.

HOLLAND VILLAGE, SINGAPORE
watercolour, 38 × 46 cm (15 × 18 in)

The figures and cars are toned down, with a minimum of detail, and do not detract from the buildings, but make it a lively scene.

In order to avoid inadvertently portraying a ghost town, do not be afraid to incorporate a few items of traffic. Realistically painted cars can indeed be harsh and inappropriate, but cars can be hinted at, kept at a distance, or softened with a figure in front, as in *Holland Village, Singapore*. A vehicle in the periphery of a picture should head towards the centre, or it will draw the viewer's eye out of the painting. I have seen many successful paintings using a red London bus or post office van as a centre of focus.

The round or elliptical form of a bicycle's wheels provide relief from the predominantly vertical and horizontal lines in street scenes. A cyclist's leaning posture has the same effect, and a solitary cyclist will stand out in a busy streetscape.

There are many other ways of indicating life in a townscape. Ensure that some windows and doors are open. A half-drawn curtain here, an open shutter there, flowers in a windowbox, are subtle touches that are sufficient to hint that the building is lived in. I seldom pass up an opportunity to use a flag or banner in a painting to depict a breeze, and of course a chance to introduce a spot of bright colour. Other artists employ different devices. James Fletcher-Watson, for example, uses to great effect clothes or other laundry hanging out of balconies, or strung across the narrow streets of Tuscany or Venice.

DEDHAM CHURCH
watercolour, 30 × 46 cm (12 × 18 in)

Grazing cattle provide a centre of focus and a sense of scale in a rural landscape scene – as well as a touch of colour.

RURAL LANDSCAPES

Figures are equally useful in country scenes. They tend to be smaller, of course, when placed in distant views, as in *Dedham Church*. In many of Constable's landscapes, you have to look quite hard to identify human figures or cows. But they are nearly always included!

Farm animals should be featured for the same purposes as human figures. They provide an indication of scale, a touch of colour, a point of interest, a centre of focus, a foil for balancing a composition. Grazing cows are my favourites, followed by sheep. Brown cows such as Jerseys are environmentally friendly: their gentle colours blend well with country tones. However, I do like placing a Friesian or two for stronger effect or as a focal

point. Their black and white markings stand out distinctly. Sheep are the easiest to paint: they can be represented as white dots in distant fields. But it helps if one or two recognizable sheep are drawn in the middle distance.

I love horses, but they are a challenge to paint convincingly. I admire the ability of John Yardley whose horses are effectively painted with a remarkable economy of strokes, and yet possess such vitality and movement.

Do not pass up the chance to use tree shapes and their foliage to depict life and movement. Sloping upper branches and leaves slanting in one direction are all that is required to indicate a breeze. Blades of grass or reeds should slope in the same direction.

Some artists are adept at including soaring birds or gulls to indicate wind and movement. This can effectively put life into marine scenes even if there is a dead calm. Waves, especially with white crests or surf, by themselves evoke energy and movement.

Finally, do not forget clouds. There can be an abundance of colour and movement in them. Look closely at some greyish clouds and you may be able

to discern numerous shades of blue, grey, mauve, red and yellow. My preferred colours for painting clouds are French Ultramarine, Cobalt Blue and occasionally Coeruleum, variously mixed with Burnt Umber and Light Red. Not infrequently, I use a dilute Raw Sienna for a warm golden yellow near the horizon, or a highlight in a white cloud. I paint mostly wet-on-wet, with a large squirrel-hair brush, leaving white patches for highlights.

The different colours, tones and textures of the sky in *Harvesting the Rice, Bali* are intended to make your eye skip from one part of the picture to another. The shape of a cloud can also indicate the direction of the wind. The leading edge of a moving cloud can be rounder, and the tail more diffuse. Streaky, wispy clouds on a sunny day imply high winds. If the wind is blowing towards the viewer, the clouds could have a V-formation.

This painting illustrates how much life and movement can be captured: the waving coconut palms, the fluttering strips of white cloth and banners (strung between bamboo poles to keep the birds away while the rice is being harvested), and the colourfully clad women. Note also how cloud shadows add texture and depth to the painting.

It is by using details of this kind that you can put life into your landscape and, by stimulating the imagination, encourage the viewer to look around.

HARVESTING THE RICE, BALI
watercolour, 30 × 46 cm (12 × 18 in)

A lively, colourful sky, with lots of activity and movement on the ground. Brightly dressed women, carrying the harvested rice in baskets on their heads, weave through the golden ricefields.

LANDSCAPE GREENS

I often have trouble mixing greens in oil paints, particularly when I am painting trees in the landscape. What mixtures are most useful?

Answered by: **Tom Robb**

Mixing greens is a problem for many leisure painters, trying to differentiate in a landscape between trees, fields, grasses, lawns and so on.

First, we need to look again at one basic assumption: trees are, in fact, not always green! Consider Cézanne and Monet – their trees are often light blue, grey, soft brown or even purple. The changes reflect the type of tree, the weather, the time of day and the season – each has its effect.

You see what you expect to see: if you think trees are always green, that is what you see. If you recognize that there are many variations, then you will be able to look objectively at the scene in front of you and pick out the changes.

NATURAL GREENS

Let us consider the times when the leaves show their natural colour, a form of green. The base of all true green pigment is Viridian. The others that are available are mixtures of two or more colours, and these you can mix on the palette. However, it is also useful to have two of the standard mixtures that come prepared in tubes: Sap Green, truly sharp and vivid, and Olive Green, rich and glowing. All the subtle variations in between you can make yourself from these three distinct greens.

Look carefully at Sap Green and Olive Green in the art shop. As mixtures they may vary from brand to brand; some are richer and stronger than others.

When mixing blue and yellow on the palette to make your third green, it can be hard to remember exactly which combination gives the colour you want. I suggest you spend some time making up colour codes for yourself, starting with a single bar on one side of Cadmium Yellow, and then working across mixing in various blues. Begin each horizontal line of squares with three parts yellow

COMBINED COLOUR CODE

I marked out the squares in pencil, leaving one bar for yellow, in this case Cadmium Yellow, and working down the colours I wanted to explore. In between, the colours are modulated starting from the left in each row, three parts yellow to one part other colour, equal parts yellow and other, then three parts other to one part yellow. Finally, the pure second colour. From the top down, on the right, the second colours are Viridian, Olive Green, Sap Green, Coeruleum, Cobalt Blue, French Ultramarine, Prussian Blue and Black.

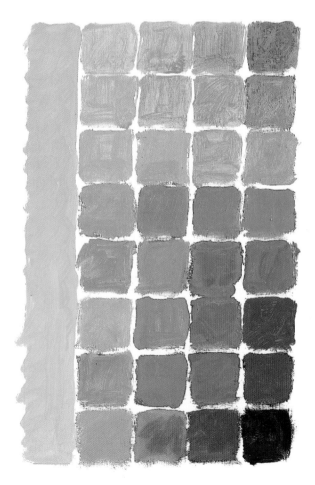

and one part blue, then put an equal mix of yellow and blue beside it, then a three parts blue and one part yellow, and finally the pure blue. You can use Coeruleum first to mix with the yellow, then Cobalt Blue to mix the line underneath, French Ultramarine for the third row and Prussian Blue for the final line.

This alone will give you 12 different greens, lovely deep colours that work well in summer landscapes; do the same with Lemon Yellow and you will have another 12 greens that are sharp and fresh, good for spring greens. For warmer, richer mixes of autumn greens try a colour code using Yellow Ochre as the base, and you will have 36 greens altogether, plus the three in your box – almost 40 variations on the theme!

It is important to start work from yellow to blue; as with all mixing you should begin with the lighter colour and add the darker in small amounts. If you try it the other way round you will need so much

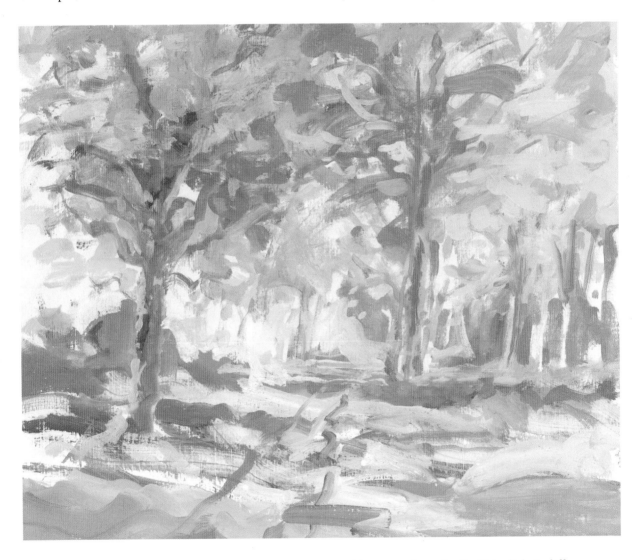

WOODLAND
oil, 27 × 32 cm (10½ × 12½ in)

Here the trees are a mixture of different species, so the greens have to be varied. On the left I used Cadmium Yellow and Coeruleum, on the right Cadmium Yellow and Olive Green to make the sharper fresh green. Then each colour was softened with blue and white to recede gradually. If the light is different, especially early in the morning and late in the evening, you may find shadows of purple and gold on the edges around the tree and on the ground. Put aside all your assumptions and try to see what is in front of you, not what you imagine because they are trees!

of the light colour that you can end up with a whole tube of paint on the palette! Make the bars broad so that each green is in a distinct square, and pin the results up in some convenient place so that you have a quick look whenever you search for just the right colour. Try using a small palette knife when mixing oil paint rather than a brush, which will soak up the individual colours into the hair and may give streaks later when you start to paint.

COLOUR COMBINATIONS

There are other combinations that give unusual greens. A very rich and valuable group comes from the unlikely mix of black and yellow. Again, it will vary depending on which black and which yellow, but any black with Cadmium Yellow will make a very luscious, warm green, which works particularly well for shadows under trees. Black and Lemon Yellow give a sharp colour perfect for spring scenes. Cadmium Orange gives some extremely useful browny greens and rich subtle shades with all the blues and blacks. Viridian itself can be altered with additional yellows to make it even brighter and cooler, or with blues to make it richer and warmer.

Any of the greens can be warmed and deepened with a touch of crimson or red, but, add only a little at a time – colours can change quickly and there is no way to go back without adding a lot of the original colours, using up much more pigment than you need.

Once you have the colour you want, you can lighten it with white, or darken it with black. For very light colours, start with white and add the colour in tiny amounts – we can learn from commercial house paints that have created whole families of tints by adding just the slightest suggestion of colour to white paint. Use black in the same cautious way.

The more colours you use the muddier the finished colour will be, so use as few as possible, even if it means a slight compromise in the colour you have in your head. Two is best, with a tiny touch of another; except for adding white or black, never use more than three. It is a good rule to keep your palette fresh and clean; this will help you reproduce more natural-looking colours.

AERIAL PERSPECTIVE

Colours can be used to convey spatial effects; as an object recedes it becomes softer in colour and more blue. You can use this effect to make trees in the distance recede by paying attention to their colour. Adding white gives you a paler shade of the colour, and to the most distant trees add a little blue. The outlines become hazier, too; a tree in the foreground may have every line clearly drawn; in the middle ground the mass of leaves are lightly interspersed with branches, while in the background the whole tree has faded to a splodge of pale blue-green.

This is another way of seeing what colours make up new ones; in each case I started with yellow, then added a touch of the second colour to get the third colour, the largest area.

Yellow Ochre + Black

Lemon Yellow + Black

Lemon Yellow + Prussian Blue

Yellow Ochre + Prussian Blue

Yellow Ochre + French Ultramarine

Yellow Ochre + Coeruleum

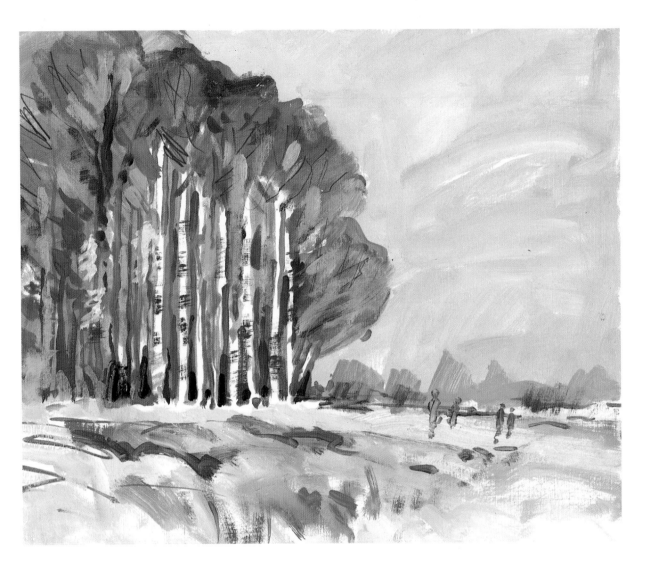

▲ WINTER

oil, 36 × 41 cm (14 × 16 in)

In the cold weather the green of a stand of birch trees disappears, leaving soft brown and sepia hazes around the prominent white bark. The trunks, marked horizontally with grey, make up the structure of the painting. These can also be spaced out by using softer shades of white that go back until there are only sepia shadows. Black and purple shadows sometimes appear in winter, too.

▶ *Here I started with Viridian for trees in the middle distance, then on the top I added white to lighten the colour as it moves back. On the bottom, I added white with a touch of blue. This creates a greater sense of hazy distance although the trees are actually the same size.*

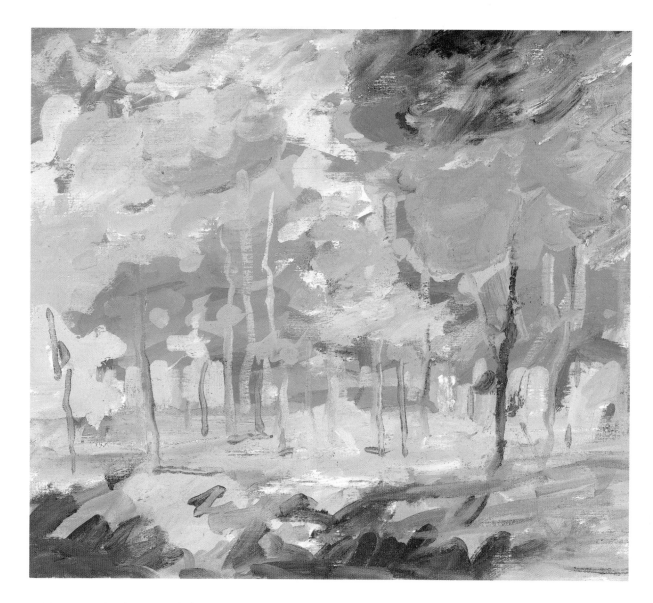

Foreground colours are the strongest; on a sunny day you may find adding a touch of Lemon Yellow catapults the green forward to let it sparkle, while on a cloudy dark day a touch of black or dark red enriches and intensifies the green foreground.

If you love painting landscapes and gardens why not take a few painting hours just to look at green? Sit where you can see a wide variety of different greens – even the average garden will have more subtle greens than you can imagine – and make up a few colour codes. Concentrate just on the colour of the leaves of the plants you can see; grey green for the caryopteris, dark green for the laurel, yellow green for the euphorbia, for instance. Make a written note of each successful mixture so next time you paint you do not have to start from scratch.

AUTUMN

oil, 30 × 35 cm (12 × 13¾ in)

Although many trees turn magnificent colours in autumn, they are seldom all red or gold at once; if you are near some trees watch them carefully over a period of weeks and you can see how the green turns little by little, with just a few highlights of red or gold, a cluster or a colouring around the edges. I used Alizarin Crimson and Yellow Ochre – warm, soft tones rather than harsher pigments.

20

STREET LIFE

How can I have street scenes that look lively – and not cluttered?

Answered by: **Gerald Green**

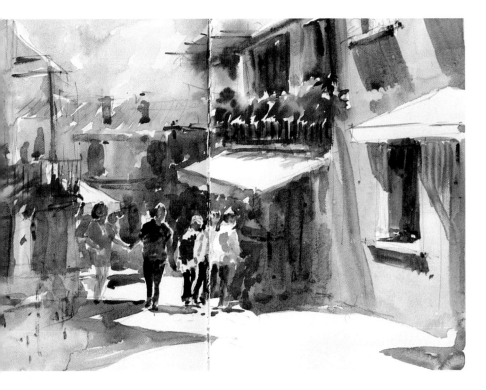

Here my aim was to record the effects of looking into the light. Studies made on the spot are an invaluable way of learning to see the essentials of your subjects. I made this 30 × 41 cm (12 × 16 in) watercolour study in a sketchbook on hot-pressed paper.

The urban environment offers a wealth of potential material for the artist, though the hustle and bustle of crowded streets, traffic noise and diesel fumes can sometimes make it feel an inhospitable place. But away from the major traffic routes and off the busiest shopping streets most towns and cities contain more appealing areas, if you are willing to search them out. Here is where you will discover street life on a more human scale in and around outdoor pavement cafés, sunlit squares or colourful street markets that reverberate with life and atmosphere. Alternatively, there are the many quieter, more secluded places where people come to find a temporary retreat from the pace of city life.

The spontaneity of watercolour makes it an ideal painting medium for capturing the immediacy of

street-life subjects, but care should be taken to avoid it becoming laboured and overworked.

WORKING METHOD

I aim to depict a more simplified, almost casual reality in my own paintings by allowing their forms to remain fairly understated, rather than attempting to produce detailed photographic likenesses of actual places. Working in this way enables me to create energy in the surface marks made on the paper. I also prefer to direct my observations towards painting focused glimpses of the particular, rather than looking for more generalized 'views'.

My method of working is either to complete a painting on location or to record and collect information by drawing, often with the addition of

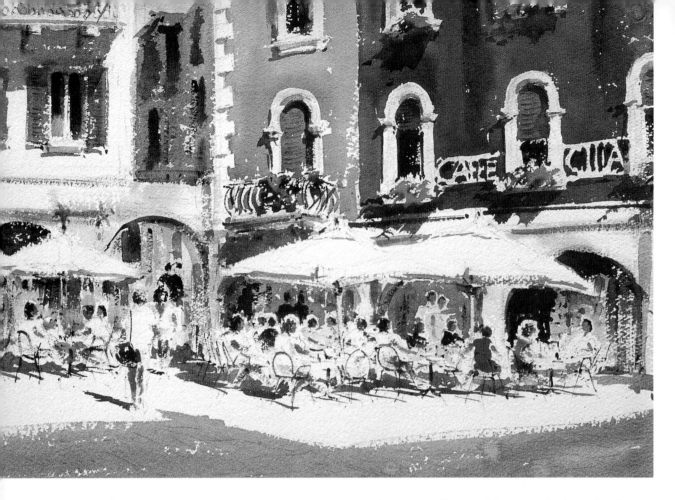

STREET CAFÉ

watercolour, 36 × 51 cm (14 × 20 in)

*The most effective way of defining lights in a painting
is to surround them with darks. To exaggerate the light
on the negative shapes of the umbrellas I contrasted
them against the darkest darks of the building behind.
I also simplified the figures at the tables into one large
shape, with only minimum definition to prevent this
complex subject from appearing too cluttered. I used
640 gsm (300 lb) rough Arches paper.*

colour notes, for possible use as the basis for future
studio paintings. Drawing can be more appropriate
on many occasions, perhaps in a busy environment
when it is not convenient to set up an easel, or
when time is at a premium.

The act of drawing is a sifting process through
which you will leave out all but the essentials of
your subjects. Also, there will be less likelihood of
onlookers when sketching, since without painting
paraphernalia it is not obvious what you are doing.

Another often overlooked determinant that can
affect the energy in a painting is the position in
which you choose to work. When painting on the
spot I prefer to work either standing up at a light
easel, or sitting on a low folding seat with my
painting surface and materials on the floor beside
me. Both these positions have the benefit of
allowing me to paint at arm's length and thus
maintain a freer, unrestricted approach to prevent
my paintings becoming too cramped. Alternatively,
working at home offers a more controlled
environment, without the added tension that
painting on the spot can bring, but here there is a
real danger of becoming almost too comfortable.

Adopting the same 'on location' painting positions for studio work, in preference to the usual comfortable chair, does go some way towards helping me to re-create some of the apprehension or edginess I need to counteract any tendency for neatness or overworking. There are, of course, advantages and disadvantages to both methods. Painting on the spot enables you to work directly from what is there before you and here a painting will normally be a direct response to what is seen. Away from the subject there is an opportunity to be more creative. Altering or rearranging elements, for example, will often enable you to improve on a composition. Often simply changing the direction of lighting can add movement to an otherwise static image. You could also try incorporating unusual or more varied colour combinations to alter and intensify the atmosphere in a painting.

MODELLING THE LIGHTS

Light enables the dynamic forms and rhythms of the urban landscape to be brought to life and is one of the main ingredients I use to energize my own paintings. The lightest lights are produced by allowing selected areas of the white paper to remain in the final image. These lights can be further intensified by placing strong contrasting darks around them, as in *Street Café* (opposite).

I do not as a general rule use masking fluid since I prefer to see the original uncertain edges left by the drawn brush marks, which also add character to the work. The inevitable controlled edge of a masked-out area would, I feel, look out of place within the overall surface marks of the painting. I often begin the painting process by laying in an underpainting to the mid-toned areas in which I flood in a variety of neat colours, allowing them to mix and randomly bleed together. This process keeps the surface alive.

I then try to complete the remainder of the painting in single applications of paint without further overpainting, always searching for the essential shapes with which to describe the subject in its simplest way.

FIGURES

Figures are another essential component since they provide movement to images of street life and I take care to ensure that they always look as though they belong in the picture. Very often figures can appear

STREET MUSICIANS
watercolour,
25 × 36 cm (10 × 14 in)

In order to make figures appear lifelike they must demonstrate a convincing gesture rather than being painted in lots of detail. I used 300 gsm (140 lb) Not paper.

◀ **CAMBRIDGE**
watercolour,
51 × 36 cm (20 × 14 in)

*Though the figures are
dominant, I have
integrated them into
the image, painting
them in the same
understated manner as
the rest of the picture.*

▶ **STREET SCENE, RIVA**
watercolour,
36 × 51 cm (14 × 20 in)

*I designed the overall
lighting pattern in this
painting to direct
attention towards the
main focal point in the
centre of the image.*

to have been placed in as an afterthought, or stand
out looking like models cut from a fashion
magazine. They do not have to be painted in
considerable detail to look convincing, but they
should convey a gesture that will give a clue to their
purpose. For example, the figure group shown in
Street Musicians on page 103 was painted with the
minimum amount of detail with all but the
essentials having been left out. Much of the figure
forms have been left as white paper, but their
gesture is clear. This method of understanding
elements helps to give added vitality or spark to a
painting and leaves something to the imagination of
the viewer. Regular sketching is the best method of
learning how to portray figures convincingly.

INTEGRATING THE WHOLE
It is essential that all the various elements in a
painting should mesh together to provide a fully
integrated whole. Well-thought-out design, value
and colour relationships will help to achieve this,
but equally important is that everything in the
image should be painted in the same manner. For
example, the edges of a painting should be painted
in the same way as the elements in the middle. In

Cambridge, though the foreground figures are a
dominant feature, I have painted them in the same
understated manner as the rest of the parts of the
image. Had I been tempted to include them in
more detail this would have over-emphasized their
presence and upset the overall balance. It could
then have appeared instead as a picture of figures set
against a background, which would have given a
less integrated whole. Similarly, the various
foreground elements in the street scene in *Street
Scene, Riva* have been allowed to remain
understated for the same reason.

The personality of any town or city is
encapsulated within the forms of its urban
landscape that, though familiar and often even
ordinary, can nevertheless be a source of continued
inspiration for painting.

BROKEN COLOUR

How can I make single-colour areas lively and interesting?

Answered by: **Jackie Simmonds**

It is, of course, perfectly possible to create a beautiful painting using flat one-colour areas throughout. Modern artists frequently use this technique, expertly juxtaposing warm and cool colours, and colour complementaries, to great effect. In fact, a very good way of creating a figurative painting with a strongly contemporary look is to forgo form – the illusion of three dimensions – in favour of energetic and interesting flat shapes that create a mosaic of colour.

However, whether you paint with flat, two-dimensional shapes, or with the illusion of three-dimensional form, there may be times when you want a large area of colour in your picture to look lively and interesting – and, for some reason, it just does not. Figurative subject matter often presents us with apparently flat, single-colour areas. Examples are: blue sky on a summer's day; a large green field in the middle-distance; a bank of dark green fir trees; a white wall, a grey road or area of paving; a yellow awning. Sometimes, no matter how carefully we design our pictures, that area within the rectangle can pose a problem if we paint it with a single, flat colour, particularly if the rest of the image is tackled in a lively way.

Sometimes, light falling on the subject will offer nuances of tone and colour to paint; a light-struck area, and a part in shadow, for instance. But what about that area of relentless blue sky? Or the green field in full sunlight, without a hint of difference in

the colour from one side to the other? Do we pick up a blue (or green) pastel, or load the brush with a specially mixed blue (or green), and use simply that? What if you finish off the pastel before completing the shape? Or worse, if you run out of liquid colour, and have to mix more, exactly the same shade? Even if you have plenty of that blue pastel, or a huge pool of colour – will that area look right? It depends on how well you have designed your picture, and whether a flat, one-coloured area 'fits' with the rest of the image. If, however, you feel a sense of dissatisfaction it may be because the area

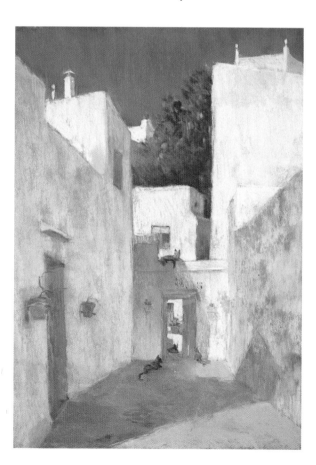

THE BLUE DOOR, VEJER DE LA FRONTERA
pastel on paper, 46 × 30 cm (18 × 12 in)

To enliven these plain white walls and single-colour ground, I used a variety of warm and cool creams, blues, pinks and lavenders throughout, to depict warm light and cooler shadows, being careful with tone values.

does not work well as a flat, single tone and colour. For those times when you feel you would like to make that colour area rather more lively, there are various ways to do it.

BROKEN COLOUR TECHNIQUES

When you use broken colour techniques, the colours you use are not physically mixed or blended together, but are placed on the paper or canvas in a way that will produce the effect of variable colour. So for an area of dense blue, such as a sky, you could place a variety of different blues on the paper that, from a distance, will read as a blue area, but instead of looking solid and flat, like a household paint card, the area will have a more lively, atmospheric quality. Broken colour effects can be achieved with an irregular random approach, or the marks you make can be much more controlled by using specific lengths of stroke, or stippled dots of uniform size, for instance. There are no rules; the choice is yours.

It is important, however, to be careful not to overdo either the number of different colours that you use, or the range of tones. An area of foliage in a landscape, for instance, could be represented by a variety of greens – and perhaps some harmonious colours adjacent to green on the colour wheel: yellows and blues. However, the area could end up rather 'jumpy' if you use too many different light and dark tones, or if you introduced every other colour on your palette!

Pastel is an excellent medium for achieving the effect of broken colour. Small strokes, or perhaps

HAMPTON COURT FLOWER SHOW
pastel on pastelboard, 56 × 71 cm (22 × 28 in)

The area of shadow in the foreground of this image presented an interesting challenge, and an opportunity to create a lively area of colour. I chose various closely toned cool colours, with both broken colour techniques, and overlaying, in order to achieve the necessary atmospheric effect. If I had used flat, single-toned colours, it would have looked like an area of patchwork, rather than shadow. I also used several different blues on the shadowed sides of the marquees.

An area of blue, created from four different sticks of blue pastel. Notice how the lightest tone of blue, the turquoise, stands out rather more than the other blues, which are much closer in tone to each other. As a result, the area is very lively indeed.

Over a dark green-blue pastel area, I stroked a lighter blue, and a dark purple, using sweeping side strokes to overlay the colours, leaving small gaps for the underlying colour to show through.

This lively patch of overall green watercolour was created with a variety of blues, greens and yellows.

Over a dry patch of pink watercolour, I used a dry brush to scumble blue, and also darker pink, for a lively textured surface and colour variety.

larger marks, in a variety of related colours, placed next to each other, will gently vibrate. The same effect can be achieved with oil and acrylic paints, and even with watercolours – although watercolour applied to a wet surface will bleed and merge, creating areas of blended colour, rather than broken colour. Broken colour effects with watercolour paint are best achieved with successive washes or marks – either onto virgin white paper, or onto previously created areas of colour that are absolutely bone dry.

SCUMBLE

A flat colour area can be made far more lively by using scumble. In oil or watercolour painting, a thin veil of colour is applied to a dry (this is important), previously painted area, using a light, scrubbing motion of the brush. This can give a wonderfully hazy, atmospheric effect. If you use close-toned colours, they will mix optically to give the impression of one colour, but with an active surface effect that is subtler than the effects achieved with broken colour. If you scumble a lighter colour over a darker one it will create a shimmering effect, and if you scumble a dark colour over a light area it will tone down the brilliance of the original colour. You can use the technique with both oil and soft pastels as well; use the side of the pastel, and lightly applied strokes, over a previously applied area, to create a grainy scumbled effect.

OVERLAYING

In all media it is possible to overlay colours, allowing small hints of the undercolour to show through successive layers. When you overlay with watercolours, the transparency of the medium will allow one colour to be seen through another, creating interesting and varied colour effects; similar effects can be achieved with glazes in oil paint or acrylics.

Although pastels are essentially opaque, nevertheless it is still possible to overlay colours, provided previous areas are sprayed with fixative. Pastel side strokes, swept across a flat colour area, will be broken up by the texture of the pastel paper so that hints of the underneath colour can be seen through the top layers.

These are a variety of techniques to consider, but it is never a good idea to get too caught up with techniques. You run the risk of the painting becoming stiff and laboured if you concentrate on technique to the exclusion of all else. However, it is a good idea to look critically at nature, and at your pictures, and occasionally make the decision to manipulate certain areas of colour, so that the finished effect is lively, painterly and interesting.

RESTING
pastel on paper, 38 × 56 cm (15 × 22 in)

Broken colour techniques are used throughout this image. The bricks were a uniform dull red; I took the liberty of introducing lots of other, low-toned colours in this area, and because all the tones are closely related, I could get away with using many colours. Also, introducing blues into this area helped to link the bricks with other places in the image where blue is used. The shadowed parts of the man's robes are painted with a variety of blues, the greenery is an abstract area of many greens, and the sunlit area of ground – in reality a solid light beige – now contains a variety of warm colours. If I had faithfully painted what I had seen – red bricks, grey shadow, and beige ground – the image would have been far less exciting.

CONTROL OF DETAIL

People tell me that the watercolours I paint are too detailed. I just paint what is there. What am I doing wrong?

Answered by: **John Lidzey**

It cannot be said that by producing highly detailed watercolours you are doing anything wrong. In other visual media hyperrealists create paintings based on photographs. They use everyday reality and turn it into art. In the same way meticulous techniques can be used by the watercolourist to produce very realistic effects. You often find

botanical paintings, for example, that are perfect in every detail – often going beyond what the camera can record. But while these works can be highly finished many can also be static and rather cold. The same might be said of many detailed paintings of other subjects. You may see landscapes and street scenes painted with great skill that remain flat and

RAINY DAY AT EARSHAM
watercolour,
24 × 22 cm (9½ × 8½ in)

The houses are based on a simple sketchbook study. I created an early-evening effect by lowering the tone of the sky and foreground. The illuminated windows also suggest the end of the day. Rain and poor visibility obscure detail in the houses and foliage. I used a comb to create a rain-like texture in the sky; with cotton buds, I wiped colour off the roofs and walls of the houses to create streaks. When the painting was quite dry I also rubbed parts of the watercolour with coarse glasspaper.

WINTER TREE

watercolour,

14 × 16 cm (5½ × 6¼ in)

A feeling of recession is suggested here by creating a background of undefined shapes and blots that can be interpreted as trees and undergrowth. The tree in the front is more detailed and painted in darker tones.

uninteresting. Yet similar subjects can be painted with less technique and attention to detail, but with more passion to produce exciting work. In addition, the exclusion or softening of detail in a watercolour can help to produce work that shows more rather than less realism.

DETAIL AND SPACE

The control of detail can be useful in conveying a sense of distance in an outdoor scene. On a clear day distant features may be seen as perfectly sharp, but interpreting them as fuzzy or with reduced clarity will help give them a far-off look.

Distant trees in a landscape might be indicated as simple shapes, in pale blued colours. Middle-distant and foreground subjects can show progressively greater definition with stronger tones and greater use of local colour (the colour that objects actually are). By gradually sharpening detail from background to foreground and strengthening tonal values from light in the distance to darker near at hand, a clear sense of recession can be achieved. When painting urban scenes it is a good idea to soften or eliminate the detail on distant buildings; such things as windows, doors, chimneys, guttering and drainpipes. Avoid the

temptation to paint the curtains in a distant window; in many cases the result looks rather odd, often killing off a sense of realism rather than enhancing it.

WEATHER CONDITIONS

Control of detail can play an important part in conveying the effect of weather on a subject. Scenes affected by fog, rain or mist can show completely muted detail and in many cases a landscape or city subject can be made to look quite atmospheric, even beautiful, but if the artist is tempted to paint in too much detail the effect will be lost. Paint less detail than can actually be seen.

In misty conditions colours are always subdued. This means that tonal contrasts should be kept weak and colours confined to low intensities. The introduction of bright colours will only spoil the result. Controlled wet-in-wet techniques can also create these atmospheric effects by having the action of softening the edges of shapes and features. If the watercolour paper is slightly dampened washes painted on top can show undefined edges, and details painted on a drying wash will show a soft outline. If this technique does not work for you another possibility is to use tissue paper or damp

In this loose painting detail is only suggested, but never clearly defined.

▶ **DUET**
watercolour, 25 × 17 cm (10 × 6½ in)

I painted this very freely, concentrating on the main shapes in the subject. The loose paintwork provides some animation to the figures that might not have been achieved with a more careful and restrained technique and approach.

CENTRE OF INTEREST

The suppression of detail can help to direct the viewer's attention to a particular part of the painting. If the centre of interest is in the foreground (as it normally is) paint the background so that it has an indistinct quality. Also, reduce the tonal strength of background features with weakened paint mixtures and diminish their intensity by adding a small amount of complementary into any colour used. A free painting style will also soften outlines.

Hall Chair shows a chair with a hat and some white material draped over the seat. The imagery shows little or no detail. The view outside the window has been wiped out and parts of the chair have been scribbled over or splashed with water and loose paint. The hat and material are the most prominent items in the composition. A completely different painting could have been created by introducing detail into the view outside the window and by defining the pattern on the curtains.

MEDIUM AND MESSAGE

There is nothing wrong with a watercolour that looks like a photograph. If it is done well the result can be effective and surprising, but the painting can lack real individuality. More importantly, it can be argued that a watercolour that looks like a photograph rejects many of the medium's wonderful effects. Exploring the full range of possible techniques (scumbling, backruns, loose brushwork, spattering etc.) can produce much more exciting work than can be found in a photograph.

cotton wool to smudge edges slightly while the watercolour is still damp. Much practice is involved in getting the best effect, so it is worthwhile spending some time experimenting on spare pieces of watercolour paper to get it just right.

The suppression of detail can also play a part in creating the effect of a windy day. Blurring outlines of trees and bushes in country scenes with suitable distortion of their form can give a very convincing impression. The effect of rain can also be created by the treatment of detail. Large shapes like buildings and trees can be broken up by using a sponge or comb to drag the paint while wet. Carefully control the direction of the resulting marks to achieve a natural effect of slanting rain.

Make small studies at home or in the studio using a previously completed painting as a reference to see how many weather conditions you can obtain.

◀ **ANNA'S ROOM**
watercolour, 53 × 38 cm (21 × 15 in)

The corner of this room is a favourite subject of mine. In my watercolour I have opted for a greatly simplified treatment. Most of the items have been reduced to quite simple shapes; the jar of flowers, for example, has been abstracted to basic marks and splodges of colour, yet the viewer has no difficulty in its interpretation. It might even be possible to name the flowers accurately.

If you want to loosen up your watercolour technique here is a good way to begin. Take a simple subject, possibly one you have previously painted. You could even use just a detail from it. Redraw and repaint it using your original as a reference. Use paper no bigger than 28 ×38 cm (11 × 15 in), preferably not less than 300 gsm (140 lb). As you paint try to keep all your edges soft. Rub edges with tissue or cotton-wool buds both while the painting is wet and dry. Leave out detail in your original that you feel can be excluded. Extend and simplify your tones. Break up the imagery by sponging out as you work. Allow water to flood into really concentrated paint while still wet. Begin to look at what you are creating more as paint on paper and less as the recording of a subject. Reduce your dependence on reality.

THE BEHOLDER'S SHARE

As a final thought it is better to give the viewer of your watercolour something to do. It is not necessary for you to paint in every detail. Often a visual hint is all you need to supply. If you are painting an autumn landscape, a field of wheat stubble can be suggested with a yellow wash and a sparse pattern of dots. Brick walls can be suggested by indicating just a few bricks and not by painting them all. If you are painting a summer scene in your garden do not attempt to paint every leaf you see; experiment with simpler methods of conveying foliage. The viewer of the painting can in many circumstances project the idea of complex foliage onto just simple splodges of colour.

Use restraint in painting detail; it will liberate your watercolours, enabling you to find a fresher, more original way of working, giving pleasure to the viewer, but more especially to yourself.

LONDON UNDERGROUND
watercolour, 29 × 15 cm (11½ × 6 in)

I killed off all detail in this watercolour. The figure is presented as little more than a silhouette with broken outside edges. I used the other end of the brush to roughen up the paint while it was wet. Shapes and edges on the platform wall have also been wiped and roughened with damp cotton wool. Neat pigment was spattered over the picture surface when dry.

DESIGN & MOVEMENT

How do I create a sense of vitality and life in my watercolours?

Answered by: **Gerald Green**

Generating and sustaining the questions of vitality and life through to the completion of a painting can be a problem for the inexperienced watercolourist. Generally these characteristics are brought about from the cumulative effect of all the elements involved in the painting process, not from any one single feature or particular painting method, but good design and movement are essential for a successful result.

In simple terms 'design' is the name given to the general placement of elements within the picture; these include shapes, lines, colours, tones and surface texture. 'Movement' is the effect of the interrelationship between these various elements. For example, vitality in a still-life group can be considerably improved when the objects are arranged with rhythmic movement between the main forms. Alternatively, the power of a turbulent seascape painting can be reduced or lost altogether if the design of the overall image is not structured effectively to consider the inherent rhythms.

LAYOUT AND COMPOSITION

It is essential that prior to beginning a painting you should be absolutely clear in your mind about what you wish it to convey. Deciding what is to be the main focus in the picture and what is of secondary importance will enable you to design the linear shape of the painting more effectively. If you initially divide your picture surface into thirds, both

Preliminary try-out compositional drawing for a proposed painting of Market Day in Mahon. *The image combines two separate sketchbook drawings, one depicting the buildings of Mahon and the second market stalls from an entirely different location.*

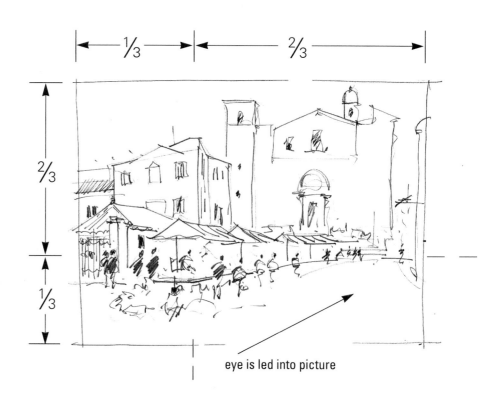

⅓ ⅔

⅔

⅓

eye is led into picture

vertically and horizontally, you can then apply the useful rule of thumb for placing the most important features of your proposed image at one of the four positions where these dividing lines intersect. This will enable you to begin to construct a balanced composition in which attention is directed towards the main theme.

Make some small pencil sketches first in order to try out your ideas and thoughts. Do not be afraid to change elements around or to adjust features. In a still-life group, for example, try out alternative arrangements, looking for the most harmonious balance between the objects. If you are painting a landscape, rearrange or adjust the features to create a more agreeable composition, even though in reality the elements may be in different places.

Producing preliminary drawings will also help you to familiarize yourself with your subject as you work so that when you begin painting you will have established the foundation of your image and you will then be able to concentrate more effectively on applying the paint.

TONAL COUNTERCHANGE

It is advisable once again to pre-plan the tonal distribution of your proposed subject by making small preliminary pencil sketches in which the main tonal areas can be tested prior to painting. The distribution of tonal values (lights and darks, irrespective of colour) within the overall image is also influential in effecting design and movement. Strong tonal contrasts, white against black or dark grey, will have the effect of advancing, while less contrasting mid greys will appear weaker, less conspicuous and therefore tend to recede into the distance of the picture.

In landscape work the direction of lighting will affect the distribution of tonal values, but this is equally important in other subjects. In order to direct the eye to the main focus of the painting try to preserve the greatest areas of tonal contrast for the main features, which should also incorporate hard-edged forms. Try to achieve a balance within the design of the overall tonal distribution; this will also help to lead the eye around the picture.

Before embarking upon the final painting valuable experience can also be gained by producing

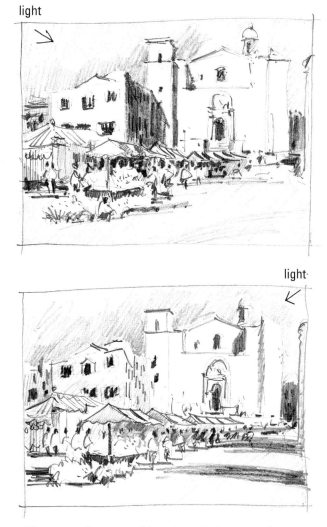

light

light

The cause of many problems in paintings can often be traced back to a confused or ill-thought-out distribution of tonal values. Producing small pencil tonal roughs like these will help you to establish a pattern of values on which your final colour work can be based.

monochrome watercolour sketches of your proposed painting. These could be produced as an alternative to the pencil sketches. Keep the shapes of the washes simple and do not be concerned with details. Any colour that will make a strong dark can be used: Sepia, Black or Indigo will work well. Begin by preserving the lightest lights as white paper and build up your washes until you establish what you consider to be the most satisfactory tonal values. This will then give you a structure on which to base your colour washes in your final painting.

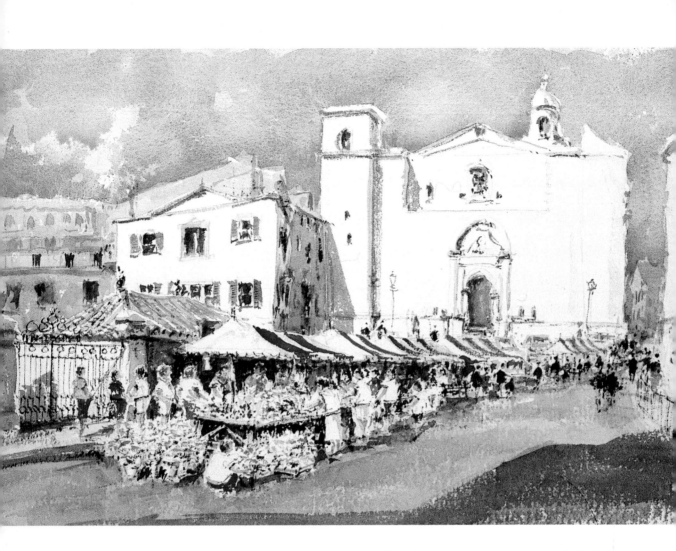

MARKET DAY IN MAHON
watercolour, 53 × 61 cm (21 × 24 in)

*The whitewashed church provides a suitable backdrop
for the receding market stalls with their colourful
awnings and bustling activity.*

COLOUR APPLICATION

Having fixed the composition or linear design of a
painting and established a suitable distribution for
the lights and darks, the final area in which design
and movement can be said to have an effect is in
the arrangement of colour and the method of
application of paint itself. Since both of these
aspects of the painting process rely to some extent
on spontaneity and personal preference it is very
difficult to offer precise rules, but there are several
pointers that will help you. Simplicity is the key
and, irrespective of subject matter, will always offer
the best results.

In order to keep watercolour work fresh it is
always preferable to apply the paint directly in one
application and to use the largest brush you can.
Take time to think about each brushstroke before
you apply it to the paper, and be clear about your
intentions. Then, boldly lay in the colour, always
resisting any tendency to fiddle about.

If you begin by working with a reduced number
of colours you will be more likely to achieve a
harmonious colour balance. Start by combining one
warm colour, either Burnt Umber or Burnt Sienna,
with one cool colour: French Ultramarine, Neutral
Tint or Payne's Grey, for example. Since these
colours will all combine to make a range of greys
this will reduce any tendency for your subsequent
colour mixing to become muddy or dirty while
working. As you become more proficient in using
these combinations, add in another colour, perhaps
Yellow Ochre or Raw Sienna, to expand the
possibilities of your palette.

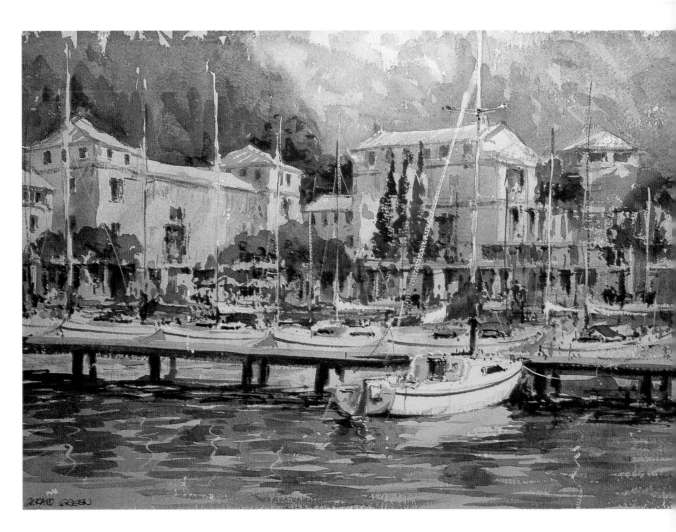

A WORKING METHOD

Initially, if you can reduce the painting process itself to a simplified three-stage operation you will be able to complete the work as a series of separate stages in which you can direct your attention to one thing at a time. This will help reduce any tendency to lose direction as you proceed. With this approach the first step should be seen as 'establishing the lights'. Having drawn in the main forms of the image in pencil, a wash of colour should be laid in broadly over the entire picture surface, allowing your chosen colours to mix freely and blend together but taking particular care to preserve the lightest lights as white paper. This is the key stage of working in watercolour.

The second and most difficult stage consists of 'modelling the forms'. Here the tonal distribution of the main forms within the overall painting is established with large colour masses, working broadly with the largest brush you can. Again, in

RIVA DEL GARDA
watercolour, 36 × 53 cm (14 × 21 in)

The design and layout of this painting were built up as described in the text, with vitality being maintained by a direct approach in which all the forms have been allowed to remain fairly understated. I used 640 gsm (300 lb) Arches Not paper.

YACHTS, GUERNSEY
watercolour, 25 × 36 cm (10 × 14 in)

This painting uses only two colours and has been executed with vigorous brush marks to provide added movement across the surface of the image. I used 640 gsm (300 lb) Arches Not paper.

order to retain life in your work it is vital to keep your approach simple and direct, resisting any tendency to fiddle once the colour washes have been laid in.

The third and final stage can be thought of as the 'finishing off', in which more detailed refinements can be added with a smaller brush if necessary. At this stage look at the overall image and maybe add in a few final touches of bright or strong colour where the painting might need an injection of life, or perhaps a dark or two here and there to refine or add further description. One final thought to bear in mind is that neatness can all too easily suffocate the life in your work; neatness has no place in painting.

Although the final outcome of any painting cannot be predetermined exactly, by adopting a well-planned approach from the outset based on sound practice you will be more able to give additional momentum to your own individuality.

Step 1

This demonstration of a small jar of flowers illustrates the basic three-stage approach. Vitality is achieved from the bold application of the medium and in this exercise this is more important than the individual colours you may choose to use. Try it first in monochrome or use just two colours, then expand your palette as your proficiency increases.

Step 1 Preserving the lights:
Having lightly sketched in the main forms of the image, watercolour is liberally applied to the entire picture except for the areas that are to remain as lights: the flowers and parts of the jar.

Step 2 Modelling the forms:
The main shapes of the leaves are added and the background darkened, again carefully preserving the lightest areas of the picture as white paper.

Step 3 Finishing off:
Finishing touches are added, colours are reinforced, and strong darks and details are added to further describe the shape of the jar.

Step 2

Step 3

RESCUE STRATEGIES

Even when I know there is something wrong with my painting, I am afraid to make changes in case I make it worse.

Answered by: **Hilary Jackson**

This is such a familiar problem. I really think that to feel at ease with any art process you must be willing to take risks. Nothing ventured, nothing gained. That is not to say that you must always take those risks on the actual piece of work that gives you the problem. There are ways to avoid making an even greater disaster.

The worst thing you can do is give up on a doubtful work and throw it away without any attempt at resolution. We learn more from failure than we do from success. Of course, deciding what is wrong in the first place can be very difficult, no matter how experienced you are. The benefit of experience is knowing ways to identify problems.

ASSESSMENT

When you look at one of your pictures, ask yourself these questions: Do I like it? (Not 'will they admire it?') Is it finished or over finished? Is it fussy? Is it tight? Does it say what I felt? What was most important about what I saw/felt, and does it say that, or something else? Is there too much going on? Is it one picture or several? What could I soften, leave out, stress or accentuate? Would it be better if I started again, more broad and free? Does it look like a picture made with that medium or is it pretending to be something else? Is it trying to be a photo?

Make notes of anything which emerges. For example: tree on left too detailed/distracting; or

Starting again:
BEECH WOODS AT KNOLE
Version 1
oil, 23 × 44 cm (9 × 17½ in)

This small study showed the scene as I saw it; the colour was naturalistic but I felt that it could be better orchestrated. The fluttery birch trees on the right served no useful purpose in the design and leaked energy out of the right-hand corner.

tonal contrast between X and Y too slight/too strong; or colour of shirt discordant with rest of portrait, etc. Fix the note to the picture until you have time to sort it out.

IDENTIFYING THE PROBLEM AREAS

'Give it time to set' is an expression I use when I suggest that leaving the picture on the landing or in a place where you will see it only occasionally is a good way to discover what is wrong with it or what needs to be done to it. If you look at the dates of some famous pictures it appears that they took a decade or more to complete, but artists often worked on their paintings at intervals over a long period until they were more satisfied – many artists still do.

Ideas and experience change, too, and this is why I always discourage students from throwing away their 'failures'. Look at your picture from a distance. Screw up your eyes till they are nearly shut and look at the work through your eyelashes. This enables you to see the overall effect without the distraction of fine detail or strong colour effects. In fact it reduces the sense of colour, which is good for analyzing tonality.

I advise my students to look at their work from a distance whenever they feel doubts about what they are doing; or look at your work in a mirror. You see the picture as you had not seen it before (flipped horizontally) so that you can be more objective, and you also see it, in effect, from twice the distance (to the mirror and back).

When viewing from a distance, cover questionable areas by holding up your thumb or hand to see how they affect the whole and whether they need to be changed. Cover areas with cut-out paper shapes and walk back to decide the effect. Question colour. It is a great temptation to use a colour 'because it was there'. The trouble with this is that in so doing we ignore such things as tone, reflection, light source, distance.

Your painting does not have to be an accurate record, but should be an expression of your response to what you saw. The painting should be unified and have what I call a 'value added' quality.

You can orchestrate the colour to make the picture say what you felt. You are allowed to edit its content to give greater impact. You can even add things to improve the effect. It is your picture and you have the final decision.

Starting again:
BEECH WOODS AT KNOLE
Version 2
oil, 36 × 46 cm (14 × 18 in)

I used a new painting board and slightly stretched the composition widthways to give more emphasis to the crossing diagonals. I left out the birch trees and brought beech tree branches diagonally across the corner to return energy to the focal area. The second version is not as pretty as the first, but I think it has more strength and gives a feeling of the darkness under the trees and the promise of the area beyond.

FLORIST'S FLOWERS
Version 1
oil, 30 × 25 cm (12 × 10 in)

Florist's flowers are almost too perfect. I enjoyed painting the vase with its cut decoration of stars, but the flowers themselves became too stiff and the composition too symmetrical.

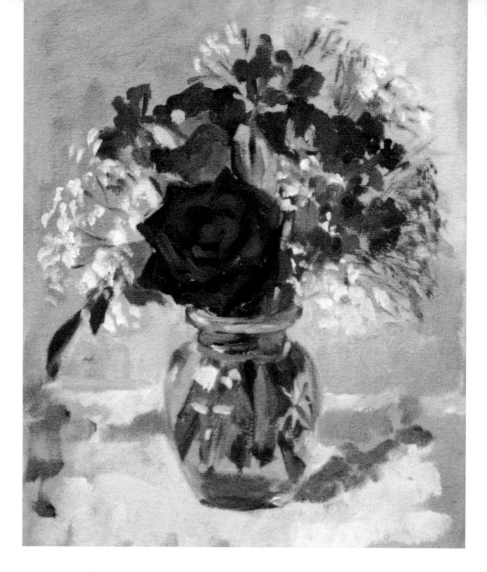

TRYING ALTERNATIVES

Having identified some of the problems, you may feel reluctant to make changes to that painting because you may lose what was there before and still not find a better solution. So do not jump straight in and make alterations to the original picture without trying out your ideas first.

To try out alterations in the composition cut strips of paper that are longer than the dimensions of your picture. Place these strips over the painting to crop its area and identify its strongest passage. Quite often you will find that there are small, very successful paintings within a boring larger one.

It is perfectly legitimate to crop a painting and this can be done easily to paper or board. You can even crop canvas, but it must be removed from its stretcher and restretched on a smaller one, which is fiddly. It might be better in any case to paint a new picture which just includes the cropped section.

To consider alterations to parts of the picture make cut-out shapes from paper that will fit over the questionable areas, and paint on these. If you paint the background colour onto the paper you can eliminate parts of the picture that seem out of place or unnecessary. If you paint several of these cut-out masks with different colours or tones or less detail, you can place each in turn over the offending area without permanently altering the picture, and you can find out which will achieve the necessary improvement you prefer.

One of the most difficult things to envisage is a change of colour scheme. You can fiddle for hours with different parts of the painting, altering the colour, and still not find the right solution.

There are ways to try this without irrevocably altering the original. Certain brands of sweets are wrapped in coloured cellophane. If you flatten out the wrappings and remove any metal foil you can look through the coloured film at your picture and

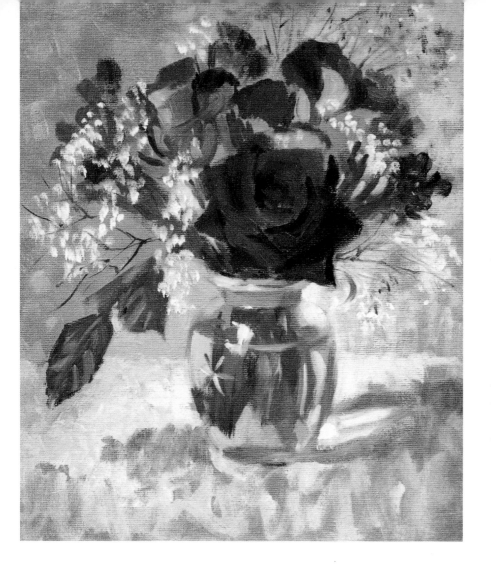

FLORIST'S FLOWERS
Version 2
oil, 30 × 25 cm (12 × 10 in)

The next day I moved the arrangement nearer to the drape to give more shadow and turned it round slightly to make it less symmetrical. The flowers had relaxed and opened more and I brought the edges of the composition in nearer. I think this picture is much more painterly and gives a better 'feel' for the subject matter, partly because I felt more relaxed when painting it for the second time.

see what it will look like with a more unified range of colour with a different colour bias. The tonal changes will not be altered, although the whole picture may look slightly darker. You can achieve the same effect with coloured tissue paper, which becomes more transparent and easier to look through if varnished with picture varnish.

If you find a colour that will unify the whole picture, use a glaze of that colour over your painting. With oils you make a glaze by adding a little linseed oil to the pigment and brushing it over the dry painting. It will take quite a long time to dry up so if it looks wrong you can wipe it off with a turpsy rag, but expect some slight changes to occur if you do.

Glazing with watercolour is perfectly possible if you use transparent pigments and it can be done several times provided each layer is completely dry before the next is added. In the

same way, you could identify smaller areas which need a colour change and either glaze or paint them in the normal way.

Another interesting way to try out new colour ways is to take a number of colour photocopies of your picture, each with a different colour bias.

Modern computer graphics packages such as *Photoshop* will adapt a scanned image to alter the colour bias of the whole or to change the colour of parts of your picture. They will even change the appearance to look like a variety of different paint or drawing media.

MAKING THE CHANGES

If it is too complicated to fix without looking over-worked or you really cannot face altering your original painting, then start another picture. It is always worthwhile to make more than one attempt at a useful subject on a fresh piece of paper or board. I have sometimes made as many as ten

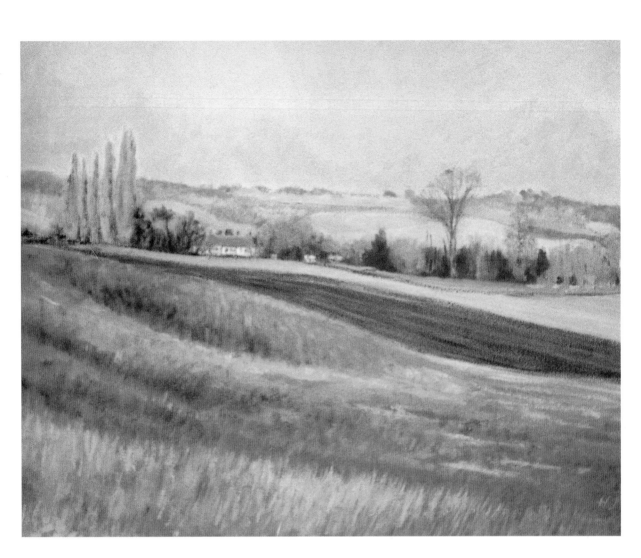

Cropping:
THE NORTH DOWNS FROM SUNDRIDGE
oil on canvas, 41 × 51 cm (16 × 20 in)

The first painting of the subject created a sense of the airy space towards the Downs and was satisfactory in that context, but I liked the area around the cottages with the golden colours of the poplars. Using strips of card to cover parts of the picture, I identified a smaller area that could make a more intimate scene (opposite).

versions of the same subject or composition with different variations of colour or emphasis or medium in each picture.

Start working on the new picture with the earlier attempts beside it so that you can watch out for the traps as you go along. When you have found the answers, or even if you never do, keep all the work involved together as you may receive more enlightenment later. To avoid despair, decide that as the picture does not work, change is inevitable, and the choice of changes can be tried out impermanently.

TO AVOID PROBLEMS
Careful planning before you start your finished picture may seem tedious, but will cut down time wasted in frustration and correction.

Make a series of rough sketches to determine the composition. Make tonal studies to decide where

the main lights and darks will be. Do this on tinted paper of a mid tone to save time. Try out rough colour plans or make colour strips. Work out several different ways to present the material using small postcard-size studies. Lay out all the options on the table or a board and choose the best. You could even make a larger, full-size study before starting the final work.

If you like the composition in one of the small studies, square it up so that you get the same proportions in the final work. So often when I assess students' work, I find that the study had enormous potential but the final picture lost something in the translation because the proportions of the composition were different.

COTTAGES AT SUNDRIDGE WITH NORTH DOWNS BEYOND
oil on canvas, 20 × 25 cm (8 × 10 in)

This is the new picture I painted from the scene I found within the larger canvas. It is a more 'cosy' composition and focuses on the cottages and the interesting colours and tones in the surrounding trees. It is no longer a picture about space and distance, so I changed the title to reflect this. I may go back and work on this study in more detail.

INDEX

Page numbers in italic refer
to captions